SPECIAL EFF
PHOTOGRAPHY HANDBOOK

ELINOR STECKER-OREL

AMHERST MEDIA, INC. ■ BUFFALO, NEW YORK

Published by:
Amherst Media, Inc.
P.O. Box 586
Buffalo, NY 14226
Fax: 716-874-4508

Publisher: Craig Alesse
Senior Editor/Designer: Richard Lynch
Associate Editor: Frances J. Hagen
Copy Editor: Ellen Bumbar
Editorial Assistants: Emily Carden, Amanda Egner
Photos by: Elinor Stecker-Orel except where noted.

ISBN: 0-936262-56-7
Library of Congress Catalog Card Number: 97-070420

Printed in the United States of America
10 9 8 7 6 5 4 3 2 1

ACKNOWLEDGEMENTS

I am grateful to several photographers who supplied ideas for some of the techniques on these pages. So, thank you Mano Orel, Tony Gezirjian, Sholom Sussman, Kenneth Dichter, and Peter North. Peter also arranged shooting sessions, posed for shots, and let me use some of his pictures, so he gets multiple thanks. Thank-you's also go to family and friends who posed for some of the pictures: Jim Merrifield, Jan Perrin, Jennifer Perrin, Nicholas Perlman, Suzanne Schulman, and Linda Shostal-Holt.

I thank Craig Alesse, publisher of Amherst Media, who persuaded me to write this book and convinced me it would be fun to do — it was. Thanks to my fine editors, Richard Lynch, Frances Hagen and Emily Carden, for an excellent job. Thanks, too, to Mark Wayne of Minolta and Bob Condra of Porter's Camera Store, who let me experiment with the wild and wonderful Cokin and Beauty filters.

Special thanks to my photographer husband, Mano Orel, who made appropriate enthusiastic sounds when I showed him my slides, took the photographs of me (even though he sawed me in half), and provided constant love and support. I dedicate this book to Mano, my love— "para polee!"

Table of Contents

Introduction

"All it takes is an open mind...and the techniques found in the following pages."

Special-effects photography lets you enter the world of imagination. Here's where you can create things on film that you could never see in the real world. You can embellish, distort, transform, and combine your images, and you don't need a computer to do it. All it takes is an open mind, a spirit of adventure, and the techniques found in the following pages.

Have you ever asked yourself — Do photographs of buildings always have to look like buildings, and must pictures of flowers look like they belong in a seed catalog? Or have you ever wondered what would happen if you zoomed the lens while you were shooting, or if you took thirty exposures on one frame of film? If so, you're ready to enter this magical world of special effects.

The fun is in creating fantastic images in your mind, then making them happen on film. Once you get the bug, you may find yourself devising your own, unique versions of a technique — or even inventing brand new ones.

Special effects break the rules. You can begin by breaking the rule of reading a book from page one to the end. Flip through this book, look at the photographs, find ideas that entice you, and try the techniques. Often techniques are fully explained elsewhere. In order not to repeat myself, I refer you to another section by "See page..."

This book assumes you know the basics of using your camera, but if there are terms you are unfamiliar with, check the glossary. Also, look in the Appendix. Here you'll find explanations of more theoretical subjects as well as suggestions for making some accessories. The suppliers list will tell you where you can find some of the more unusual products mentioned.

Many creative techniques depend on your being able to control certain camera functions, such as shutter speed or aperture. The necessary camera capabilities are listed for each effect (this may rule out using a simple point-and-shoot camera for some effects). Don't forget, if you have a camera with aperture priority but not shutter priority, changing the aperture changes the shutter speed and vice versa.

In many cases, you won't know the results of your efforts until the film is developed, so take shots in several different ways, varying the camera settings, lighting, and setups, as appropriate. Keep detailed notes on each shot so you can repeat your most successful images.

CHAPTER ONE

Focus Effects

"...throwing things out of focus can sometimes make beautiful pictures."

Making sure things are in focus is usually one of the important commandments of photography. Creatively speaking, throwing things out of focus can sometimes make beautiful pictures.

Controlling focus is easy if your camera can be focused manually. If the camera is completely automatic, you probably can fool it by focusing on something much closer or farther away than your subject; then, keeping your finger lightly pressed on the shutter-release button, lock in that focusing point while you reposition your camera. Check your camera manual to be sure you can do this.

Unfocused Subjects

You can create a mysterious or even a romantic picture by letting your subject be out of focus but distinctive enough to be recognizable. The subject should be simple, without confusing detail, and should contrast well with the background.

Check with the depth-of-field preview if your camera has this feature. You can throw subjects out of focus most easily if you use a large aperture and a telephoto lens.

Selective Focus

Throwing everything out of focus except one subject can make the most beautiful pictures. The blur you create in front and back of the subject surrounds it with color, isolates and emphasizes it.

For example, try it with a field of flowers, focusing on just one flower in the middle of the field. Or have a person hold some flowers in front of himself; focus on the flowers and let the face be blurred in the background. Keep the depth of field shallow by using a telephoto lens of at least 100mm and a wide-open aperture.

A variation is to support a sheet of glass about six inches above a table. Put objects on each layer, then focus on one of the layers of objects.

Above: The soft colors and contours of a deliberately out-of-focus subject can be lovely.
Below: Selective focus isolates your subject by keeping it sharp and blurring everything around it.

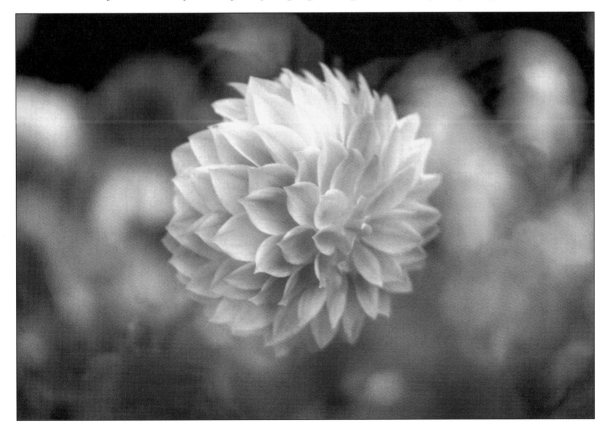

Focus Modifiers

If you put a mask with a fancy-shaped hole in front of your lens, it will transform out-of-focus highlights into the shape of the opening. The opening can be simple or complex. You can buy focus-modifier masks that fit a matte box or filter holder, or make them yourself with black cardboard. (See Appendix)

You can even hold the mask with your hand. Make the mask large enough to cover the front of your lens and hold it with one hand. The diameter of your shaped hole should be about one inch.

If your mask has a shape with a definite top and bottom, such as a heart or candle, make sure the out-of-focus highlight is behind your focused subject; if it's in front, the shaped highlight will be upside down.

How To Do It

1. Find a scene where the highlights are relatively large and bright — not pinpoints of light. This will make it easier to see the modified shape.

2. Use a 100mm or longer lens and a wide-open aperture; this will keep the modifier itself from showing.

3. Focus the lens and take a TTL meter reading; lock in those settings.

4. Put on the focus modifier and take the picture.

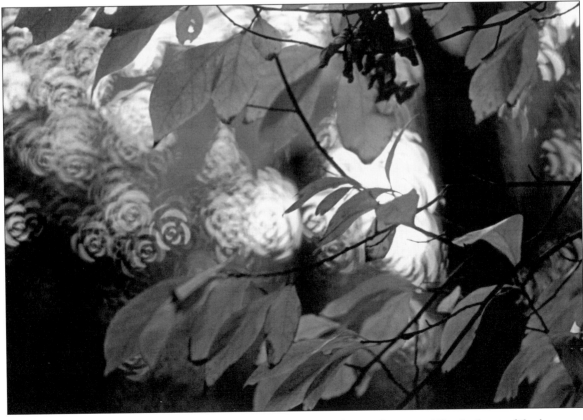

Above: *Out-of-focus highlights don't have to be nondescript blurs. A focus modifier in front of the lens can turn them into roses or all kinds of shapes.*

Defocus Zoom

To surround your subject with the radiating lines you'd get by zooming the lens and the glowing halo of an in-and-out-of-focus double exposure, all you have to do is slowly turn your camera's focusing ring during a long exposure.

 Camera Requirement: Manual focus control

How To Do It

1. You'll need slow film and perhaps a neutral-density filter, unless you're shooting in very dim light.

2. Use a telephoto lens and a large aperture to keep a shallow depth of field.

3. Place your camera on a tripod.

4. Plan on an exposure of about eight or ten seconds.

5. Focus on the subject placed as close as possible to the lens.

6. Start the exposure.

7. After three or four seconds, slowly turn the focusing ring as far as it will go.

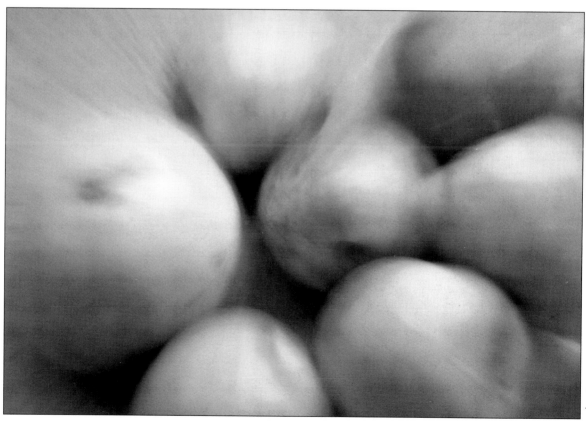

Above: *Focus on a close subject, then turn the lens's focusing ring to surround the subject with radiating lines during a long exposure.*

CHAPTER TWO

Blur Effects

Moving the Camera

"...paint swirls or streaks of colors around your subject."

The first thing you learned about photography was that you absolutely, positively had to hold the camera steady. But by moving the camera during a long exposure, you can paint swirls or streaks of color around your subject. You can move the camera side to side, up and down, around in a circle — any way you like. Follow a few simple guidelines so your camera movements look as if you created them deliberately, not by mistake.

 Camera Requirement: Controllable shutter speeds

How To Do It

1. Set your shutter speed to 1/4 sec or slower.

2. Choose an evenly illuminated, colorful scene without bright and dark patches.

3. Make sure there is contrast between subject and background.

4. Plan where you want the camera movement to start and end. Check that the subject stays in the frame and that there are no distracting objects in the frame.

5. Rehearse the movement several times before you make the actual exposure.

6. Start moving the camera before you release the shutter, and continue moving it after the shutter closes.

7. Since you can't see what you will actually get on the film, take a lot of shots at different shutter speeds and with different movement speeds. Too little blur looks like a mistake; too much blur and you'll get an undifferentiated mass of color. Keep notes so you will know what works best for you.

The Movements

Vertical. Move the camera up or down (try both ways). This effect emphasizes loftiness.

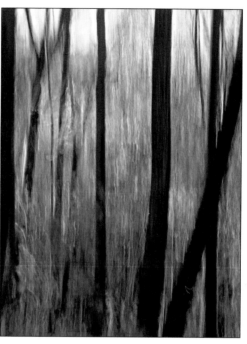

Above: *Move the camera vertically, and the resulting streaks accentuate the height of the trees.*

Horizontal. Move the camera from left to right (or right to left) to make horizontal streaks of color.

"...make horizontal
streaks of color."

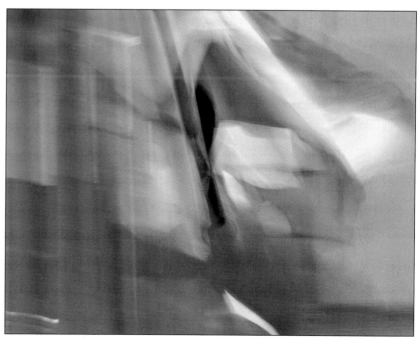

Above: *A horizontal camera movement adds an abstract quality to this picture of flags.*

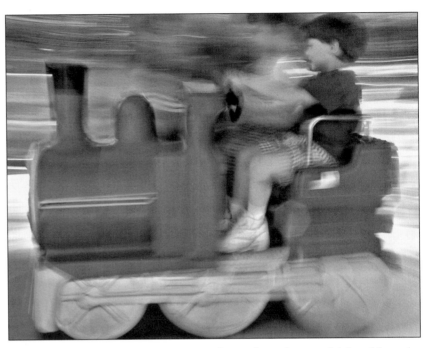

Above: *Panning the camera created streaking lines, which add to the impression of movement.*

Panning. Move your camera horizontally while photographing a subject that's moving in the same direction. If you move at the exact speed of the subject, you will produce a sharp image of the subject against a streaked background. Move your entire upper body, not just your head and hands. You can use a shutter speed between 1/8 sec and 1/125 sec, depending on the subject's speed and how large it is in the frame.

"...produce a sharp image of the subject against a streaked background."

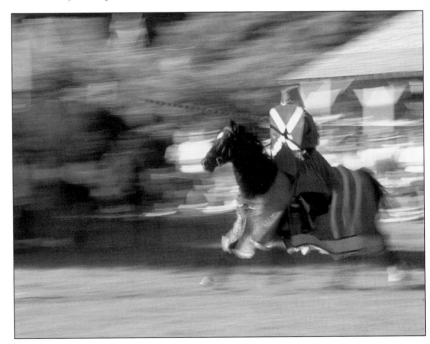

Above: *In this panning shot, the horse's hooves have almost disappeared because they were moving faster than its body.*

Diagonal. Move the camera diagonally, either upward or downward. A slight diagonal movement makes the colors look like a painter's brush stroke.

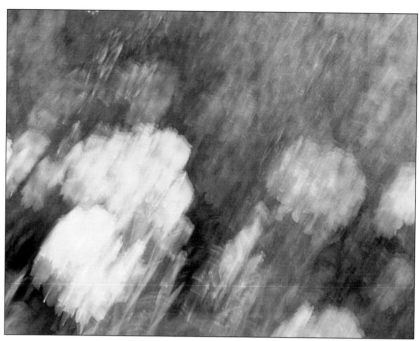

Above: *Moving the camera diagonally gives a "painting" look to flowers and other colorful subjects.*

Rotational. Rotate the camera by moving your arms in an arc. Or hold the camera still, point it upwards, and twirl yourself around. If you place the pivot point in the center of the frame, you'll get a complete circle; if it's near the frame edge, you'll get a semicircle.

"...hold the camera still, point it upwards, and twirl yourself around."

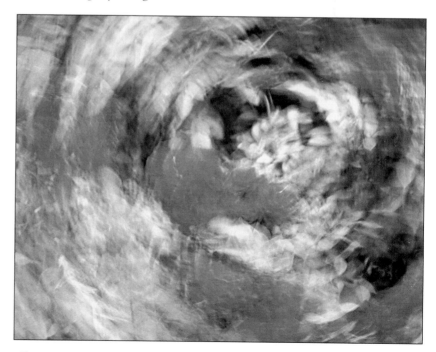

Above: *Moving your camera in an arc gives a rotational movement.*

Above: *Moving the camera in a series of W's made wavy lines out of these autumn leaves.*

Jerky. Move the camera as if you were making a series of W's, U's, or O's.

Zooming. For this effect, you'll need a zoom lens. Set the shutter speed at 1 second, and as you release the shutter, zoom the lens. The resulting image will have a sharp center which will be surrounded by radiating streaks. You can also zoom on a very close subject by putting a close-up attachment over your zoom lens.

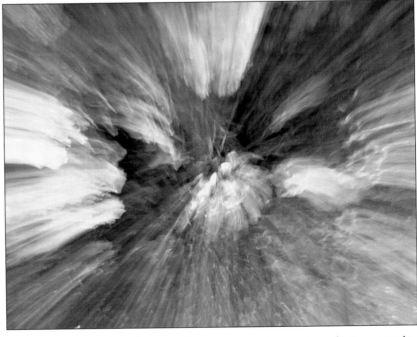

Above: *Zoom the lens during a long exposure to create radiating streaks.*

Ideas to Try

- Use a one-second shutter speed. Begin or end with a pause, or make a series of pauses during any of the above movements. It's especially effective when you zoom.

- Try a horizontal movement on a vertical subject and vice versa.

- Shoot from a moving vehicle. Try it from the side and rear windows as well as the front. Passengers only. See page 65 for a variation when shooting at night, streaking the lights from cars and signs.

- Put the camera on a tripod and jiggle it by hitting a leg or the center column during the exposure.

- Hop, skip, jump, walk, or run while making an exposure. Or take the camera for a ride on a swing, slide, or seesaw.

- Combine movements, such as zooming and moving the camera.

- Pan the camera at a rate somewhat slower than the subject is moving; the subject will blur a bit, emphasizing a feeling of frenzy.

Subject Movement

Use a fast shutter speed with a fast-moving subject and you can freeze it in mid-motion. If the shutter speed is just slightly too slow, you'll get a blurred picture suitable only for the wastebasket. Use a very slow shutter speed, and the blur can make the picture convey the feeling of movement. The slower the shutter speed, the more blurring you'll get. Moving water, whether it be waterfalls, fountains, or oceans, becomes a beautiful gossamer veil. When photographing people, you can blur just the legs and feet of someone riding a stationary bike, or just the swirling dress of a dancer.

"...the blur can make the picture convey the feeling of movement."

Above: *The whirl of dancers' skirts is captured with a slow shutter speed.*

 Camera Requirement: Controllable shutter speeds

How To Do It

1. Put the camera on a tripod so nothing but the moving subject will blur.

2. Frame the subject so it will stay within your viewfinder frame during the exposure. (You won't be able to see through the viewfinder of an SLR camera when the shutter is open).

3. The subject should contrast with the background, either in color or in tone; otherwise, they will merge. Light-colored subjects against a dark background work best.

4. Experiment with different shutter speeds, from 1/8 to eight seconds. The faster the subject's movement, the faster you can set the shutter speed.

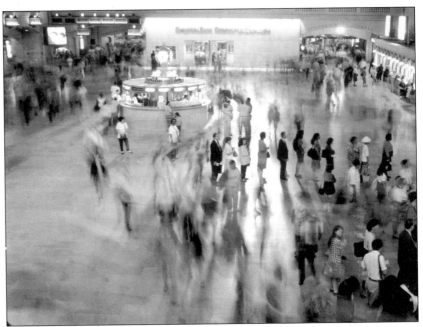

Above: *Grand Central Station. A shutter speed of several seconds made most of the moving people vanish; only those in line for tickets stood still long enough to be imaged on the film.*

Ideas to Try

- Use a shutter speed of about five seconds to make moving subjects completely vanish, especially if they are wearing dark clothing.

- Tilt the camera at an angle to create an effect of urgency.

- Use a long exposure to produce subject blur, but overexpose the image about one stop to make somewhat ghostly images.

- Have the subject hold still during part of the exposure time, or fire a flash during the exposure. This will give you an unsharp image along with a sharp one. (See page 50)

Right: This tree actually had drab, brown leaves against a slightly blue sky. A purple POP filter changed it into the eye-popping colors you see here.

Below: If a sunset is too dull, just use a color filter, like this yellow one, to liven up the scene.

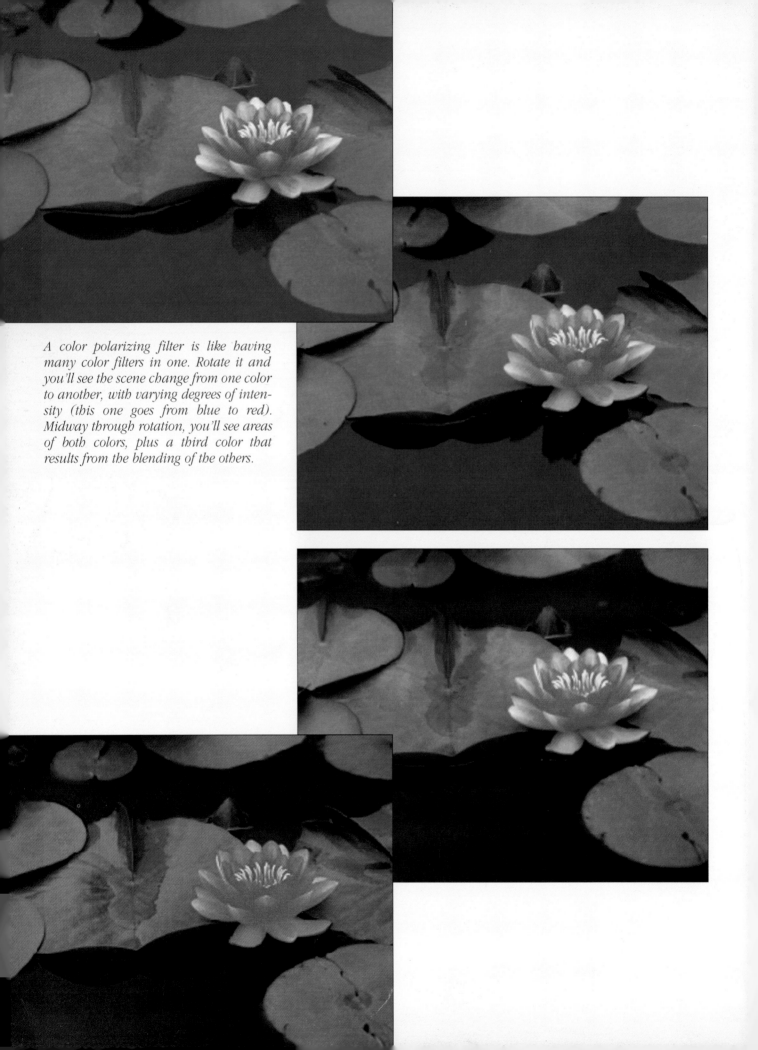

A color polarizing filter is like having many color filters in one. Rotate it and you'll see the scene change from one color to another, with varying degrees of intensity (this one goes from blue to red). Midway through rotation, you'll see areas of both colors, plus a third color that results from the blending of the others.

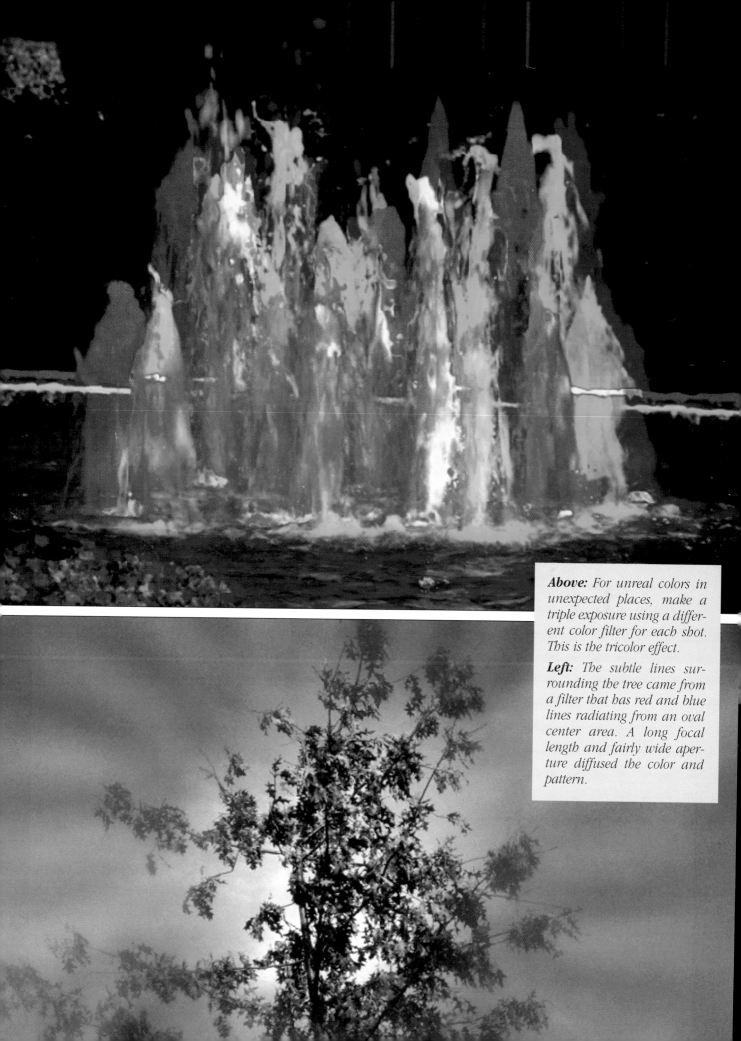

Above: For unreal colors in unexpected places, make a triple exposure using a different color filter for each shot. This is the tricolor effect.

Left: The subtle lines surrounding the tree came from a filter that has red and blue lines radiating from an oval center area. A long focal length and fairly wide aperture diffused the color and pattern.

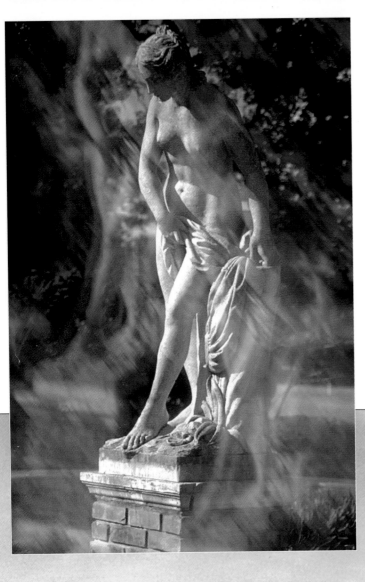

Left: A linear diffraction filter alters reality by breaking light into long streaks of its component colors.

Above: To spotlight the flowers, I used two filters over my lens: a solid yellow and an orange color-spot.

Bottom: Nature wasn't ready when I was, so I added my own rainbow with a rainbow filter.

CHAPTER THREE

Filters and Front Lens Attachments

Filters

"...transform your pictures from subtly different to outrageously fantastic."

A bit of glass or plastic can transform your pictures from subtly different to outrageously fantastic. Filters come in a tantalizing array from several manufacturers, although no one company makes all the different types. You'll also find similar filters from several manufacturers but under different names, so they are described generically. You can even make some filters yourself.

Some special-effects filters have a hole in the center; you'll have to use a lens shade or your hand to make sure that light doesn't bounce off the edge of the hole. With many special-effects filters, the camera aperture influences the result. Check with your depth-of-field preview if you have one. After you've used several types of filters individually, experiment with combining them. You may not like all the results, but you'll have fun trying.

Mounting Systems

Threaded Filters. Round glass filters, available in different diameters, screw onto the filter threads of your lens. If the diameter isn't marked on the lens, look inside the lens cap. If you have lenses of different diameters, buy filters to fit the largest lens. They will be more expensive, but you can use them with other lenses by adding a step-up ring.

Slotted holder. The Cokin and similar systems use a holder that screws onto the lens. The filters, which may be square or round, then slip into slots on the holder. You can insert a square filter all the way or partially, whichever gives the effect you want.

Gelatin-film filter holder. This device holds 3 X 3-inch thin gelatin filters in front of the lens. These filters are less expensive than others but need more careful handling.

Matte box. Sometimes called a compendium hood — it has an expandable bellows, which lets it act as a lens shade, and it has a slot in back for square

or gelatin filters. Its most useful feature is the front slot that can hold masks and vignetters.

Magnetic system. The Master Control System is unique in that it has a magnetic base. This allows you to change filters rapidly by just slapping them over the lens instead of screwing them on each time. You can use threaded filters mounted in metal holders, gelatin filters, and all manner of masks.

Colored Filters

Filters come in all the colors of the spectrum, letting you change the landscape to something never seen in reality. Most of these filters are available in a range of densities. They also reduce some light reaching the film, so you'll have to increase your exposure. Just let your TTL meter do the work. You'll probably want to use fast film and a tripod if the filter is very dense.

Filter Types

Filters for black-and-white film. Color filters designed to make tonal relationships look normal on black-and-white prints.

Light-balancing (color conversion) filters. Amber and blue filters that modify the light entering the camera to match the type of color film.

POP filters. Filters with strongly saturated colors in wild shades such as purple, aqua, rose, and others.

Color graduated. Filters with color that gradually fades to clear. Some are available in intense shades.

Split color. Filters with two colors, one on each half, and filters with three colors arranged in pie-shaped wedges.

Multicolor. Filters with irregular dabs of color and a clear center. On some filters, the colors are randomly scattered; on others, they are evenly spaced geometric designs. Either way, the filter surrounds the subject with multicolored blurs.

Color spot. Color filter with a clear center; it surrounds the subject with color. The hole is usually round, but you'll also find holes with oval and other shapes, or filters with several holes.

Color polarizers. These come in several color combinations (red/blue, blue/yellow, etc.). As you rotate the filter, the color gradually changes from one to the other. Even more intriguing, at a midway point, you may see areas with each color plus a third color that results from the blending of the others. (See page 18)

Technical Details

Filters with more than one color: A small aperture and short focal length makes the transition between colors more distinct; a large aperture and long focal length makes the transition softer. Check the effect with your depth-of-field preview.

Filters with a clear center area: As with multicolored filters, a small aperture

Colored filter product shot.

and short focal length makes the transition between the clear area and the color, sharper and more distinct; a large aperture and long focal length makes the transition softer. Also, a short focal-length lens makes the center area smaller and clearer; a telephoto lens makes it larger and the subject within it more diffused. A large aperture makes the center area large but also very diffused; a small aperture does make the clear area a bit smaller, but the subject will be sharp. A good compromise is a focal length around 50mm and an aperture of f/5.6 or f/8.

When using filters with geometric designs around a clear area, use a large aperture or long focal length to put a blur of color around your subject; use the opposite to bring the pattern into focus. (See page 19)

With filters with color or pattern around a clear area, use manual-exposure mode and take the meter reading without the filter in place, or use your in-camera spot meter if you have one. This will give you a correctly exposed subject with a slightly dark colored surrounding area.

When you're using print film and a filter that colors the entire scene, inform the lab what you have done. Otherwise they will attempt to neutralize the color, and the result may not be what you intended.

"Try a sepia filter to add an old-time look."

Ideas to Try

- Deep blue filter to turn day into night. Deliberately underexpose one or two stops, and avoid including the sun.

- Deep orange, red, or yellow filter to exaggerate a sunset, or go wild and try a green or purple filter.

- Orange filter to add a warm mood to a desert scene, blue filter to make a snowscape look icy cold.

- Light green filter to intensify a scenic that's primarily green; other color filters to intensify the dominant color in a scene.

- Sepia filter to add an old-time look.

- Purple POP filter to turn drab brown leaves to red, yellow flowers to orange, and turquoise objects to blue. (See page 17)

- Two differently colored graduated filters, placed so a different color is on the top and on bottom. If you insert them partially, you can leave a clear area in between.

- Color spot to surround the subject with a blur of the predominant or radically different color.

- Color spot combined with a solid-color filter to give different colorations to the center and surrounding area. (See page 20)

Make-Your-Own Filters

Get clear and colored acetate from an art-supply store. Although it's not optically clear, such acetate works fine for occasional special effects. After making your filter, simply hold it in front of your camera or put it in a gelatin-filter holder. You can tape two or three pieces of colored acetate together.

Or take clear acetate and paint it with translucent paints or markers, cutting a hole in the center to leave a clear area for the subject. You can paint patterns or irregular blobs of color. (See page 39)

Tricolor Effect

This is a knock-your-socks-off effect, with unreal colors in unexpected places. You'll be doing a triple exposure using a specific color filter for each shot. Various parts of a moving subject will be colored differently by the filters, but the natural colors of static subjects will be unchanged. Read about color theory in the Appendix, and check out the section on multiple exposures. (See pages 19, 37, 38 for tricolor effect.)

The technique requires specific filter combinations: filters number 25 red, 61 deep green, and 38A blue. Or you can use 25 red, 58 green, and 47 blue. These combinations will keep the color of a static subject unchanged. Color negative film can allow the print to be corrected if the neutral areas are off, but a slide film such as Fujichrome Velvia gives you more colorful results.

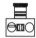 **Camera Requirement:** Multiple-exposure capability, TTL metering, manual ISO

How To Do It

1. Choose a scene with a white, moving subject such as water, clouds, smoke, or moving lights.

2. Put the camera on a tripod and set for three exposures.

3. Set the film-speed dial to three times the film's ISO.

4. With water or other rapidly moving subject, use shutter-priority mode and the fastest shutter speed you can use with the blue filter.

5. Make three exposures, one through each filter, taking extreme care not to move the camera.

Ideas to Try

- Use a zoom lens, change the focal length and filter for each exposure.

- Change the lens focal length, but stack the filters in a different sequence.

- Shift the camera slightly, horizontally or vertically, between shots.

- Include a main subject in one of the exposures, or have a person stand in a different place for each exposure. This produces colored ghosts.

- Choose a scene with objects that are dark instead of white.

- Photograph a wall with the shadow of a person or other object. Make one exposure with the shadow and two without it. You'll get a colored shadow. With an inanimate object, make two exposures with the shadow and one without. Or use the shadow of a different object or person for each exposure.

"This is a knock-your-socks-off effect…"

- Wait five or ten minutes between shots, allowing sunlight and shadows to move.

- Shoot moving lights at night, making a single exposure of ten seconds or more, and change the filters during the shot.

- Use these filter combinations: orange, dark green, and dark blue; purple, turquoise, and rose POP filters.

Diffraction Filters

Aim at any light source, reflected highlight, or bright object, and put a diffraction filter over your lens. Like a prism, the filter breaks light into its component colors: White light will show all the colors of the spectrum; yellow will have bits of red and green. There are several types of diffraction filters, and each creates a different pattern. The linear type adds long streaks of color, the radial filter rings the subject with a halo of colored rays, still another creates a four-pointed star with bands of colors in the points.

These filters add a slight amount of diffusion, especially in bright scenes, but they don't cause any light loss and don't bother automatic focus or automatic exposure systems. For the most dramatic effects, photograph subjects that are in front of a dark background, or darken the sky with a polarizer. Otherwise, underexpose one stop to brighten the colors. Wide-angle lenses produce sharp, distinct rays, while telephoto lenses spread them out.

"...underexpose one stop to brighten the colors."

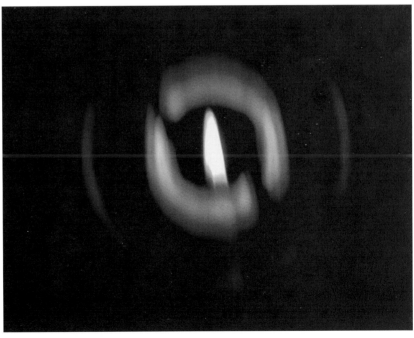

Above: *Rotating a radial diffraction filter during a long exposure moves the rays into a swirl of three concentric colors. (See color picture page 20)*

Ideas to Try

- Shoot sunlight bursting through leaves or glancing off water, or the sun partially hidden by a tree or other object.

- Add even more color to colorful neon signs at night.

- Instead of a halo of color surrounding a light, make the halo partially surround your subject. Compose the picture so the subject is in front of the light, partially obscuring it.

- Put the camera on a tripod and center the viewfinder on a small light source. Use a one-second exposure, and rotate a radial-type filter while making the exposure. You will surround the light with a triple-colored circle.

- Pan the camera to make colored streaks. (See page 12)

- Use the linear filter to photograph a light-colored subject that has no points of light. The filter will produce secondary, colored images around the subject.

- Make a double exposure of a scene that has many lights, repositioning the camera slightly or changing the lens focal length between shots.

- Use a color filter with the diffraction filter.

Multi-Image Prisms

These remarkable pieces of glass or acrylic can turn one image into multiple identical images, in concentric, radial, or side-by-side patterns.

Take into consideration the lens focal length and aperture, since these usually affect the results. If your camera doesn't have a depth-of-field preview button, follow the suggestions and make notes so you can repeat the effects you like.

"...turn one image into multiple identical images..."

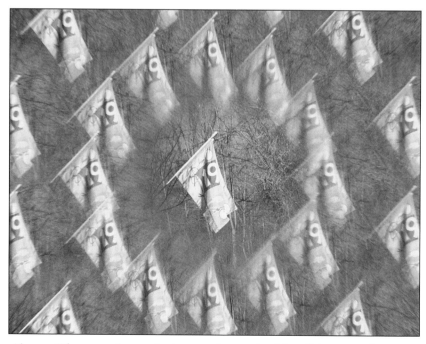

Above: *When one image isn't enough, maybe 25 will be. A multi-image prism filter is all it takes to clone your subject.*

"...produce sharper images with better color saturation."

Above: *A parallel multi-image prism changed a single bend into this dizzying path.*

 Camera Requirement: Aperture control

Filter Types

Three-section to twenty-five-section prisms, arranged in pie-shaped wedges.

Four and five sections grouped around a central section.

Three parallel sections of equal width.

Four, five, or six parallel sections in just one half of the filter. These are sometimes called "repeater" filters.

Variable prisms that you adjust to produce two or four sections with varying angles.

Color multi-image prism with two, three, or six sections, each colored differently.

Technical Details

Focal length. The longer the focal length, the more separated the images will be; the shorter the focal length, the more the images will overlap. Focal lengths of 50mm to 100mm work best, but check what the manufacturer specifies for a particular filter.

Aperture. Smaller apertures separate the individual images and produce sharper images with better color saturation, but they also cause the actual sections of the prism to become visible. Larger apertures softly blend the images. With the repeater filter, the larger aperture gives more images. The best compromise is an aperture of f/5.6 or f/8.

Subject-to-camera distance. The farther the subject is from the camera, the more separated and less distinct the images will be and the more empty space in the picture. Closer is better.

Contrast. The best subjects are those with good contrast and clearly defined outlines.

Backgrounds. Dark backgrounds make the images most distinct; bright ones tend to wash out the image.

Subject size. The more images the filter makes, the smaller your subject must be to fit into the image area.

Ideas to Try

- Emphasize excitement and confusion with a multi-image filter.

- Highlight the subject by using a color-spot filter along with a multi-image filter that has a central **image**. (See page 22)

- Combine a multi-image filter with a color filter, color-graduated filter, or double mask. (See page 22 and 47)

- Put the camera on a tripod, use a slow shutter speed, and zoom the lens while using a multi-image filter that has a central section.

- Put the camera on a tripod, use a slow shutter speed, and rotate the ring of a multi-image filter that has a central section. You'll surround the central image with a whirl of color. (See page 39)

Blurry Streaks

"...sweep motion into a static picture..."

Filters with descriptive names like Cyclone, Windmill, Mars, and Breeze can sweep motion into a static picture or swirl an unattractive background into patterns of color. One type effectively mimics the streaks you get when you zoom the lens, another seems to illuminate a grove of trees with rays of sunlight. These filters have a clear area surrounded by lines molded or etched into the glass. The lines create streaks and whirls around a sharp image.

Technical Details

It's best to shoot with a focal length of 50mm or shorter with these filters to keep the center image sharp and the streaky lines distinct. Although small apertures make the central area clear, the edge of a dark area is noticeable, instead of merging softly with the lines surrounding it. The best apertures are f/5.6 and f/8.

Camera Requirement: Manual control of aperture and focus

How To Do It

1. If the clear area of the filter is not in the center, focus the lens before putting on the filter.

2. Set the aperture to f/5.6 or f/8.

3. Make sure light is not reflecting off the edge of the hole in the filter.

4. Compose and shoot.

"...surround a subject with lines that streak in various directions."

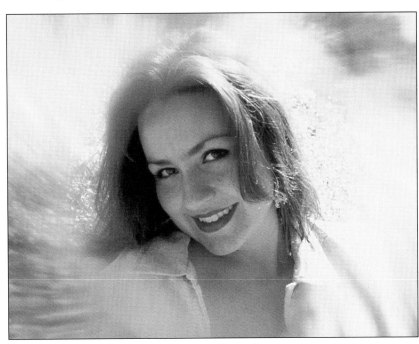

Above: Some filters can surround a subject with lines that streak in various directions. The one used here adds gentle curves.

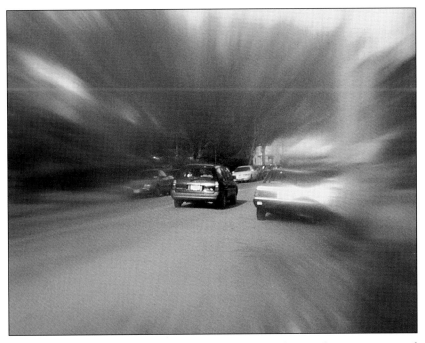

Above: This filter, on the other hand, adds lines that make it appear as if you zoomed your lens.

Make Your Own

Take a clear or skylight filter and add your own patterns with a small dab of petroleum jelly (Vaseline). Use a cotton swab or your finger to smear the petroleum jelly, leaving a clear spot in the center. You can also use a piece of clear acetate and cut a hole in the center. The lines in the image will smear at right angles to the lines of your smearing. (You can observe this effect in your car on a rainy night — look at what happens when lights fall on the area being smeared by your windshield wipers.)

Diffusion Filters (Diffusers)

Older women love them...glamorous women love them...romantic still-life and scenic photographers love them. These "soft-focus" filters soften hard edges, lower contrast, mute colors, and add a slight shimmering halo around highlights.

When you do special effects photography, you can use these filters to turn out dreamy, misty, romantic photographs. Diffusion filters come in several strengths to give you the amount of mistiness you feel is right for the mood you want to create.

Fog filters and star filters with closely spaced grids are also wonderful for softening the image. Center-sharp filters let you diffuse all but the center of the image; these can camouflage a distracting background or emphasize one subject in a group. You'll also find colored diffusion filters and colored diffusion filters with a clear center.

Cokin's Dream filters create a soft halo effect around the subject or points of light. The result is much like the in-and-out-of-focus double exposure effect described on page 48. It's especially striking with light subjects against a dark background.

Above: *Use a diffusion filter over your lens to create a dreamy, misty scene.*

How To Do It

1. Soft lighting is best. Backlighting and sidelighting are especially nice.

2. You can use any focal-length lens from 28mm to 135mm.

3. Unless you are using very heavy diffusion, you can focus with the filter in place.

4. Generally, use a wide-open aperture; closing down the lens reduces the effect with some filters.

5. Take your meter reading with the diffuser in place. Heavy diffusion may cause the meter to overexpose, which actually enhances the effect on color film.

6. With a center-sharp diffuser, stay with a focal length of about 50mm and an aperture of f/5.6 or f/8.

7. Special considerations with the Cokin Dream filter: The best effects are with telephoto lenses and large apertures. If the lens is stopped down too far, the subject will be surrounded by a sharp outline rather than a diffused halo. A good setup is a 100mm lens at f/5.6. A light subject against a dark background gives the most noticeable effect.

Ideas to Try

- Use a color filter or graduated color filter along with the diffusion filter.

- Overexpose by a 1/2, one, or two stops.

- Use a center-spot diffusion filter with color that is similar to the subject or the area surrounding the subject.

- Zoom the lens during the exposure.

Make-Your-Own

- If you have nothing else, simply blow on your lens and shoot quickly before the condensation evaporates.

- Take a clear or skylight filter and coat it with hair spray, dabs of clear nail polish, or a thin layer of petroleum jelly. Leave the center clear if you wish.

- Take a skylight filter and use a fine-point black marker, such as Pilot SC-UF, and cover it with tiny dots.

- One of the best diffusers is simply several layers of black net.

- Hold a piece of crumpled cellophane or acetate in front of your lens.

Above: _Pretty woman, not-so-nice background? Hide the surroundings with a center-sharp filter._

Stars

With a star filter in front of your lens, you can turn every bright point of light into a gleaming star! Your stars can have two rays — or four, six, eight, or even sixteen rays. It depends on the filter you choose. The rays can be long, short, or both. One type of filter is actually in two rotatable sections, allowing you to change the angle and number of rays.

"...turn every bright point of light into a gleaming star!"

"The more intersecting lines, the more rays the stars will have."

Star filters are made with a grid of fine lines etched into their surface. The more intersecting lines, the more rays the stars will have. Also, the closer the lines (grids of 1mm and 2mm), and the more lines there are, the brighter your stars will be. Widely spaced lines produce a halo-like glow. Star filters create a bit of diffusion, especially at wider lens apertures or longer focal lengths.

The secret of creating a dazzling star is to find a very bright point of light, especially one against a dark background. Small points of light give bright stars with long rays. If the light source is broad, you'll get broad beams instead of narrow, sharp rays, but sometimes that is also effective. If the light is dim or too far away, forget it — the result will be a dim star or none at all.

Your light source can be actual lights, such as street lights, car headlights, or Christmas tree lights. Or the source can be highlights reflected in a glass, metal, diamonds, or any shiny surface.

Above: *A star filter is used to turn bright points of light into dazzling stars.*

 Camera Requirement: Manual exposure control

How To Do It

1. Find or place an intense point of light against a dark background.

2. Choose an F-stop in the middle of the aperture range, probably about f/5.6 or f/8.

3. Take your meter reading from the main subject where it won't be influenced by the bright points of light or the background. Do this without the filter in place.

4. Focus with or without the filter in place

5. Rotate the filter to position the rays.

Ideas to Try

- Stack two star filters together. This will produce more rays and also more diffusion.

- Use a color filter along with a star filter.

- Partially block your view of the sun with a tree or building, and use the star filter to create the sun's rays.

- Place a small piece of aluminum foil, tiny mirror, or other reflective material wherever you want a star, and shine a light on it.

- Photograph rippling water with sunlight reflecting off the waves. The effect is subtle, but the filter gives extra sparkle to the water.

- Use a macro or close-up lens to photograph light reflected in drops of water.

Make Your Own

Use a piece of ordinary window screen in front of your lens. Hold it in place or put it in a filter-frame holder.

Miscellaneous Filters

Here are some filters that don't fit into any special category, but you'll certainly want to look at the wonders they can produce.

Rainbows

If nature isn't ready when you are, create your own rainbows whenever or wherever you want them with a rainbow filter.

Your rainbows will be realistic if you use a wide-angle lens and a large aperture, or go to the other extreme and make unnaturally brilliant multi-colored arches. (See page 20)

 Camera Requirement: Aperture control

How To Do It

1. Rotate the rainbow filter to position the arc. If you want it to look realistic, work on a somewhat overcast day and make sure one or both ends of the arc stop at the horizon or merge with the side of the frame. If you want to be unrealistic, place it wherever it suits your fancy.

2. Use a focal length in the 20mm to 50mm range, with 28mm being optimum.

3. Stop down the lens to about f/8. The longer the focal length, the more you must stop down.

"...create your own rainbows whenever or wherever you want them..."

Do It Yourself

You can draw your own rainbow on a 4 x 5-inch piece of clear acetate. Use transparent markers that adhere to acetate, such as those intended for overhead transparencies.

Speed Filter

An easy-to-use speed filter can leave a trail of streaky, blurred lines behind your subject and make it look like it's really zipping along. Half the filter is flat, the other curved. It's the curved part that smears and streaks lines. Rotate the filter and you can make the speed lines go in any direction.

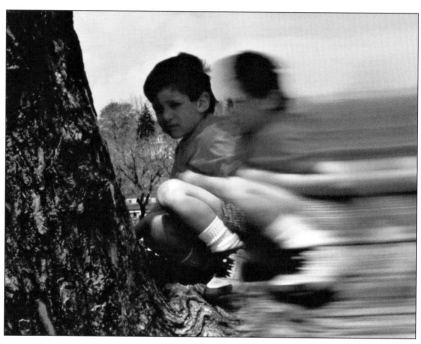

Above: A speed filter makes this child appear to be moving faster than a speeding bullet, but he was actually sitting quietly in a tree.

> "The best subjects are those that contrast well with the background..."

The best subjects are those that contrast well with the background and have lots of detail and color. Almost any lens up to 250mm is fine. With long lenses, you'll want to stop down to a small aperture. Your camera won't be able to focus automatically, so either focus before you put on the filter, or focus manually after the filter is in place.

 Camera Requirement: Manual focus control

Ideas to Try

- Place the speed lines at an angle instead of horizontally if the background is plain.

- Add speed lines to statues and other objects that obviously can't move.

- Use the speed lines vertically to add a delicate blur at the top of a row of trees, weeds, or other vertical subject.

Masks and Vignetters

Filters are not the only devices you can put in front of your lens to modify an image. Masks and vignetters can also produce unusual photos.

Shaped Masks

Masks are pieces of vinyl or lightweight cardboard with a shaped opening. How about a sneaky look through an old-fashioned keyhole, or placing a pretty face within a heart? A mask lets you compose your subject within a shaped opening surrounded by black. You use it in a matte box placed over the lens. Another type of mask lets you make creative double exposures.

"...a sneaky look through an old-fashioned key hole..."

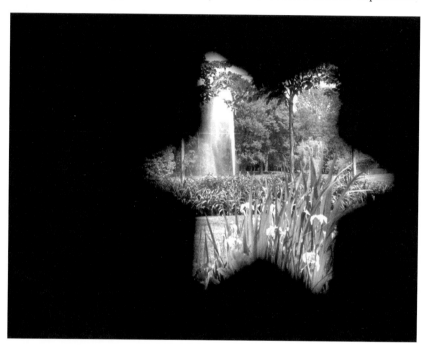

Above: *Rectangles can be boring, so go ahead and change the contour of the picture by putting a shaped mask in front of your lens.*

 Camera Requirement: Aperture control

How To Do It

1. Select a lens focal length — the longer the lens, the larger the opening.

2. Take your TTL meter reading before you put the mask in the matte box; otherwise, the black surrounding area will cause the picture to be overexposed.

3. Use an aperture of f/16 or smaller and extend the bellows as far as possible from the lens. This will keep the edge of the opening sharp.

Make Your Own

You may want a mask in the shape of your company logo, Mickey Mouse, or other simple shapes not available commercially. Draw or trace the shape

on a piece of lightweight, black cardboard that will fit in your filter holder or matte box, then carefully cut it out with an art knife (X-acto with a number 11 blade).

Vignetters

Vignetters, like masks, are made of rigid vinyl and have an opening in the middle. Unlike a mask, a vignetter's opening has ragged edges. The opening is usually round, oval, or often just a semicircle that covers about a third of the frame. Vignetters may be somewhat translucent, and may be white, brown, black, or even colored. The beauty of a photograph, especially a portrait, when shot with a vignetter, is that the image gradually fades off into the solid color of the surrounding area.

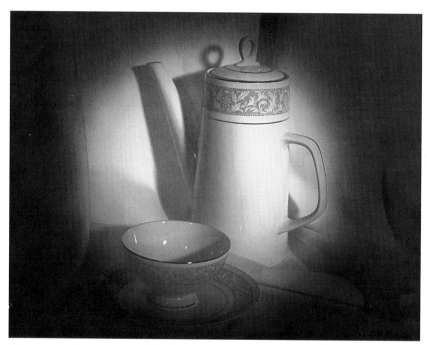

Above: *A vignetter gently fades your subject into the surroundings.*

 Camera Requirement: Manual exposure control

How To Do It

1. Select a lens focal length and take a TTL reading, as with masks. The longer the lens, the larger the opening.

2. Use a large aperture and retract the bellows to keep the edge fuzzy and make the transition soft.

Make Your Own

Cut a piece of frosted acetate or lightweight vinyl so it fits in a filter holder or matte box, then cut a hole with an art knife. Or enhance the effect by cutting the hole with scissors that make an irregular edge. If you wish, color the vignetter with one or even several colors of transparent paint.

These are variations of the triclolor effect: a triple exposure using red, green and blue filters.

Right: *For each exposure, I removed one of the vases that was casting the shadows, and I used a different color filter.*

Below: *I changed the lens focal length and the filter for each of the three exposures.*

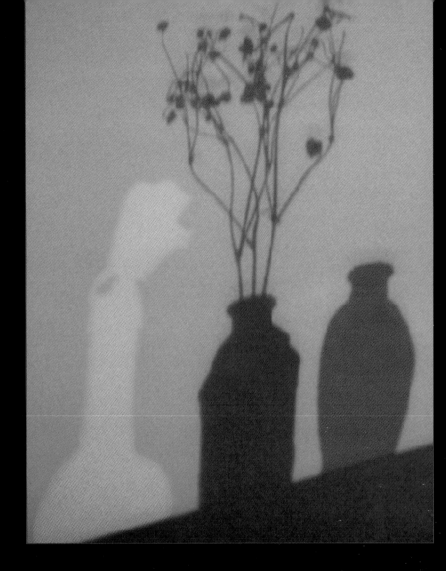

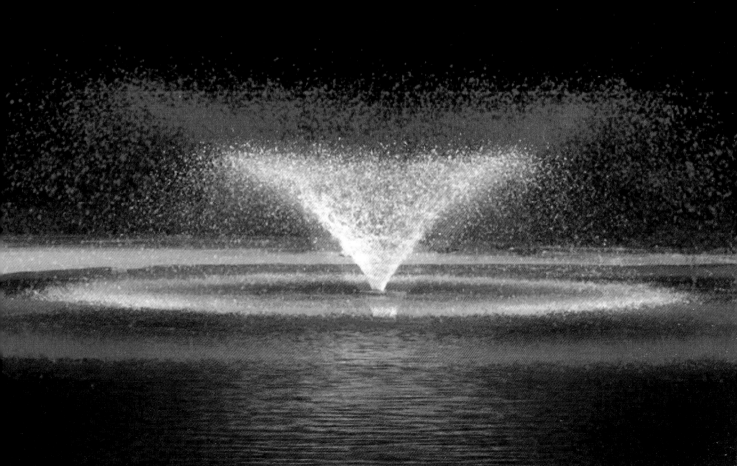

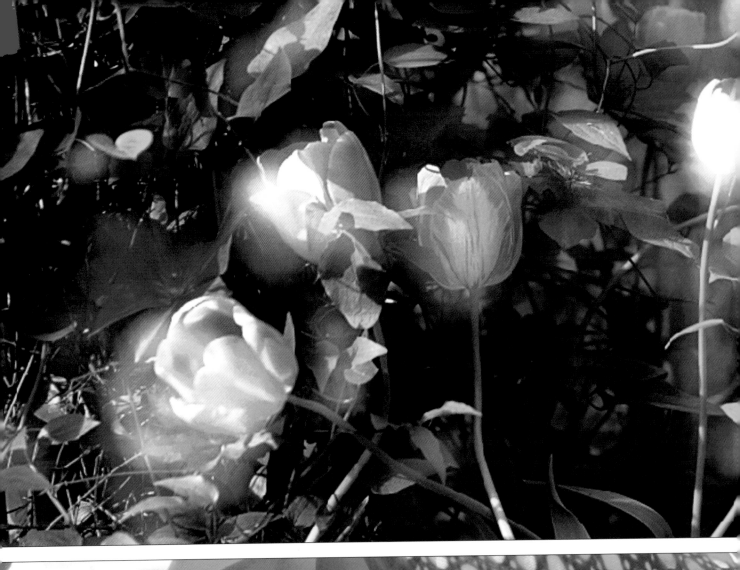

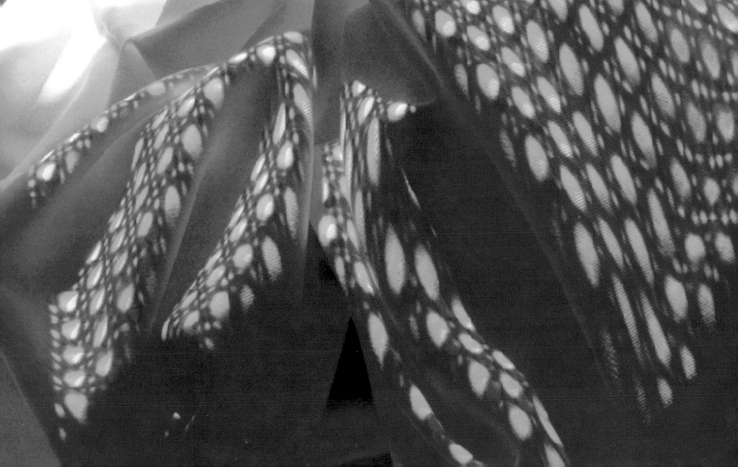

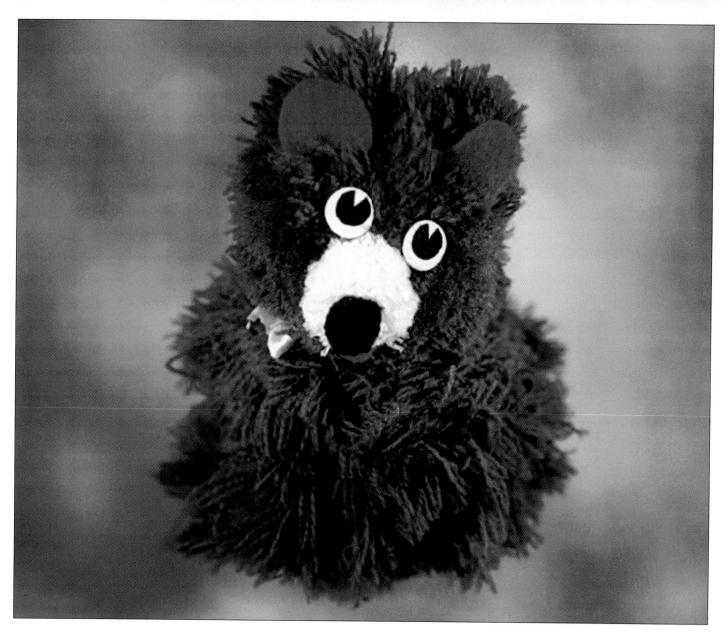

Upper left: *The glow around the bright areas is caused by a double exposure, one in focus and one out-of-focus.*

Left: *I waited five minutes between exposures when making a triple exposure of light coming through the holes of a cane-back chair. Tricolor technique.*

Above: *I painted clear acetate with blobs of transparent paint, cut a hole in the middle, and used it to photograph this teddy bear.*

Right: *By rotating a multi-image filter that has a stationary center, I was able to surround the flowers with a swirl of color.*

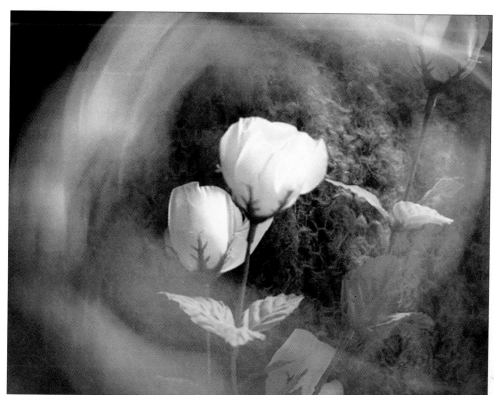

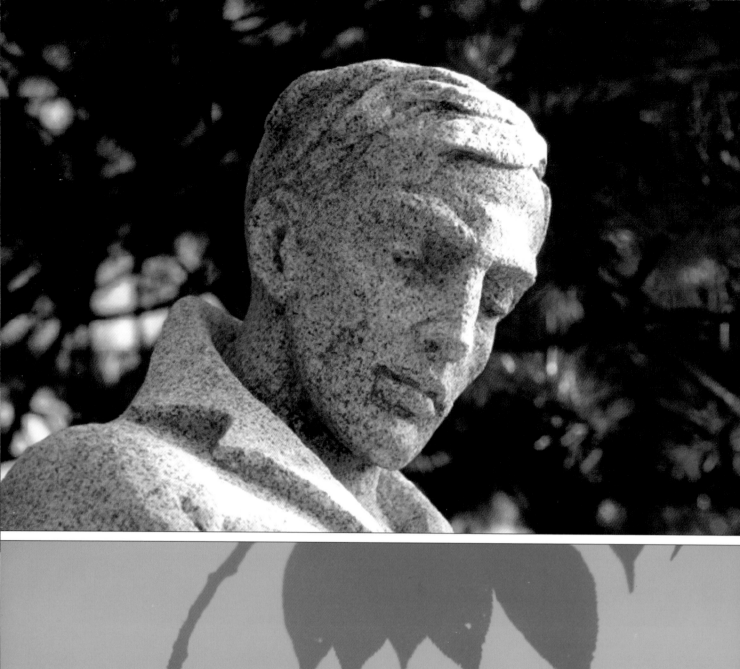

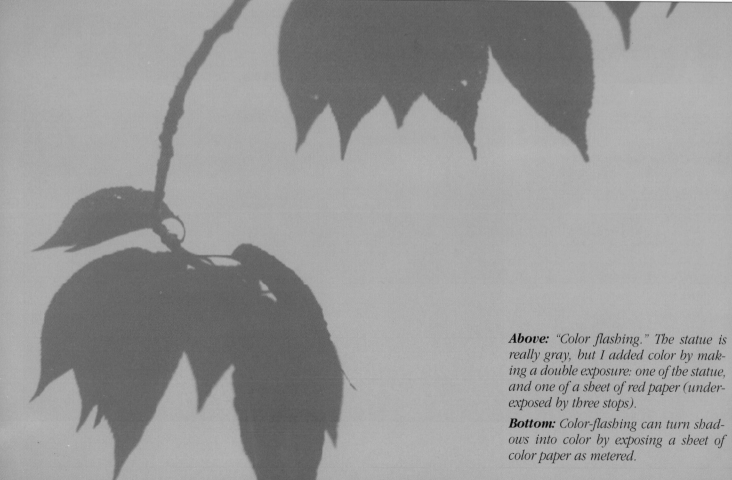

Above: *"Color flashing." The statue is really gray, but I added color by making a double exposure: one of the statue, and one of a sheet of red paper (underexposed by three stops).*

Bottom: *Color-flashing can turn shadows into color by exposing a sheet of color paper as metered.*

Filters with Clear Central Area

	Center Sharp	**Color Spot**	**Streaky**
Large aperture	Center area large and diffused; transition gradual	Center area large and diffused; transition gradual	Center area large and diffused; transition gradual
Small aperture	Center area small and clear; transition sharply defined	Center area small and clear; transition sharply defined	Center area small and clear; transition sharply defined
Best aperture	f/5.6-f/8	f/5.6-f/8	f/5.6-f/8
Long focal length	Center area large and very diffused; transition gradual	Center area large and very diffused; transition gradual	Center area large and diffused; transition gradual; streaky lines blurred
Short focal length	Center area small and clear; transition sharply defined	Center area small and clear; transition sharply defined	Center area small and clear; transition sharply defined; streaky lines distinct
Best focal length	50mm	50mm	50mm or shorter

Multi-Image Filters

Large aperture	Blended images, less sharp. Repeater prism has more images
Small aperture	Separated images, sharper, more color saturated; sections of prism visible
Best aperture	f/5.6-f/8
Long focal length	Separated images close to edge of frame
Short focal length	Overlapping images near center of frame
Best focal length	50-100mm
Subject far from camera	Images separated and close to frame edge

Quick Guide to Using Special Effects Filters

	Best focal length	Best aperture	Other Suggestions
Center spot Color spot	50mm	f/5.6-f/8	
Colored pattern	Wide angle gives sharp pattern; telephoto gives diffused color	Small aperture gives sharp pattern; large aperture gives diffused color	
Multi-image and repeater	50mm to 100mm	f/5.6-f/8	Subject close to camera for more images
Streaky	50mm or less	f/5.6-f/8	
Diffusion	28mm-135mm	Large aperture	Overexpose to enhance effect
Stars		f/5.6-f/8	Bright light sources, dark background
Diffraction	Wide angle for sharper rays		Dark background enhances colors
Shaped Mask	Telephoto gives large opening	Very small aperture	Put mask far as possible from lens
Vignetter	Telephoto gives large opening	Very large aperture	
Speed	Up to 250mm	Small aperture with tele lenses	
Dream	50mm or longer	Large aperture	Light subject, dark background
Rainbow	20mm to 35mm	f/8 or smaller	Small aperture gives brighter, sharper bow
Double exposure half mask		f/4-f/8 with wide angle; f/8-f/22 with tele	
Positive/negative paired masks	50mm to 100mm	f/5.6-f/8	

CHAPTER FOUR

Multiple Exposures

Double Exposures: Nonoverlapping Images

"...add a moon to a dark sky..."

Your camera's multiple-exposure feature will let you add a moon to a dark sky, make a photograph with two images of the same person, or create a photograph that looks as if it were painted with a brush. When an area of the scene is black or deeply shadowed, that part of the film will not be exposed, and you can use it to record a second or even third image.

It's a good idea to sketch a diagram of the final image so you know where to position the subject(s) so the images won't overlap. Then use some mark within the viewfinder as a reference point when you shoot. A grid-type focusing screen is invaluable, but you can easily use the center focusing circle, data indicators, or even dust spots as reference points.

Instead of making two successive shots, you can do them weeks and miles apart. Shoot an entire roll of film, rewind, and refrigerate it in a plastic bag until you're ready to use it again. Later, let the film warm up to room temperature, reload it, and make your second shot of any desired foreground.

Double Portrait of One Person

This is a nice way to show different aspects of a person. You might photograph two front views; profile and front view; full length and head shot; left and right profiles back-to-back of a dark-haired model. You can even do three exposures or color each exposure differently.

 Camera Requirement: Manual exposure control, multiple-exposure capability

How To Do It

1. Place the subject against a black or very dark background, adjust your camera position so you see it in one part of the frame.

2. Take your meter reading close to the subject, where the black background cannot influence the meter.

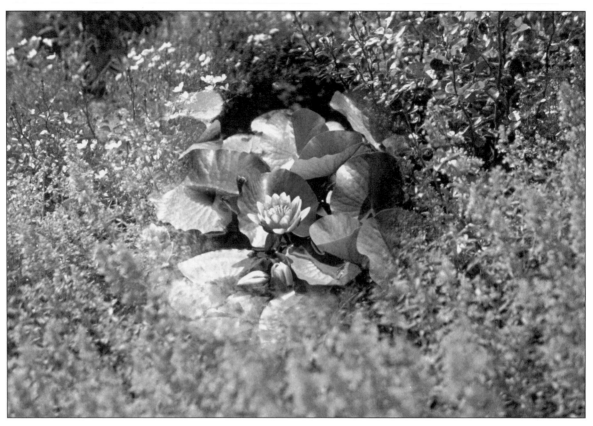

Above: In the real world, you'd never see a water lily in a field of flowers. But with a double mask and a double exposure, you can put a picture of anything in a picture of anything else.

3. Prepare the camera for a double exposure.

4. Take the first picture.

5. Reframe the subject in another part of the frame.

6. Make the second exposure.

Light Up the Sky

Here's the way to add the moon, fireworks, lightning, or any other bright object to a dark sky.

 Camera Requirement: Manual exposure control, double exposure capability

How To Do It

1. Take a landscape picture that has a dark sky, basing your exposure on the light area of the scene.

2. Prepare your camera for a double exposure

3. Make a second exposure of the moon or other bright object that has a black or very dark background. Frame it so it will fall within the area of the sky in the first exposure.

New Configurations

Just as black subjects will not expose your film, white subjects will completely expose it and a second exposure will have no effect in that area. This opens some clever possibilities.

 Camera Requirement: Manual exposure control, double exposure capability

Shaped Images

How To Do It

1. Shoot a silhouetted subject or shape against a white or light background.

2. Prepare your camera for a double exposure.

3. Make your second image of a normally illuminated subject, larger than the silhouetted shape, so the important part falls within the black area. The result will be the first subject shaped like the silhouette.

The Painterly Touch

Brush black paint on a sheet of white paper. . .

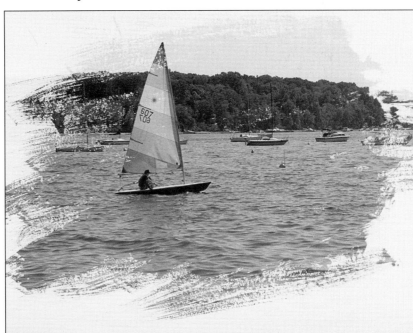

Above: _. . . then make a double exposure of it with a picturesque scene. The result is a picture that looks as if it were painted._

How To Do It

1. Paint a large black area with irregular edges in the middle of a sheet of heavy white paper. Use poster paint, which dries with a matte surface.

2. Take your meter reading from an 18 percent gray card placed over the painting. This will ensure that the black area will photograph as dark as possible, and that the white area will completely expose the film.

3. Photograph the entire sheet of paper, including the white area.

4. Prepare your camera for a double exposure.

5. Focus on the subject of your "painting."

6. Meter the subject normally, and make the second exposure. Be sure the subject is positioned within the dark area.

Ideas to Try

- Paint an oval, star, or other shape on the white paper.

- Underexpose the painted paper by one or two stops. This will surround your image with a faint image instead of a white area.

Double-Exposure Mask:
Turn Your Subject into Twins

This effect is similar to the double portrait described on page 43, but this time your subject can be in any location, not just against a black background. The secret lies in using a mask that covers exactly half the lens. This way, you expose just half the scene at a time, either right and left or top and bottom.

Camera Requirement: Manual exposure control, double exposure capability

How To Do It

1. Place your camera on a tripod.

2. Place your subject on one side of the frame.

3. Meter the subject without the mask and set the exposure manually. Use an aperture in the range of f/4 and f/8 for a wide-angle lens, or f/8 and f/22 for a telephoto lens.

4. Cover half the lens with the mask, checking its position with your depth-of-field preview, if you have this feature.

5. Make the first exposure

6. Have the subject move to the other side of the frame.

7. Reposition the mask so it covers the other half of the lens, and make the second exposure.

Idea to Try

- Position a person on the left side of the frame. Put the mask in the holder so it covers the person from the waist down, and make the first exposure. Have the model move to the right side of the frame, mask the lens so it covers the model from the waist up, and make the second exposure.

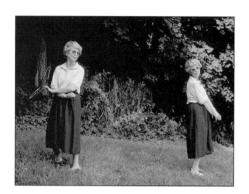

My husband created two of me by making a double exposure with a mask that covered half the lens. Photo by Mano Orel

Insert the mask horizontally to "saw" your subject in half. Photo by Mano Orel

Double Mask: Picture within a Picture

You can place one image in the center of another, such as a face within some flowers or a detail of a scene within a wider view. You'll need a pair of complementary double masks. They're available either as glass filters or as vinyl inserts for a matte box. One mask is clear with a black circle in the center, the other is exactly the same, but has a black background with a clear circle.

Images with similar tonalities seem to work best together. Wide-angle lenses produce a smaller center spot, while telephoto lenses make it larger. A good lens choice is one with a focal length between 50mm and 100mm, set at an aperture around f/5.6.

 Camera Requirement: Aperture control, double-exposure capability

How To Do It

1. Meter each subject without the mask, and set the exposure manually. Until you are familiar with the technique, go for a soft transition by using a wide aperture.

2. Place one mask in the holder, using the center circle of the camera's focusing screen to position it in the center.

3. Make the first shot.

4. Before you remove the first mask, insert the second one and align them. When the viewfinder is completely black, you know it's perfectly positioned.

5. Do not change the aperture or focal length.

6. Remove the first mask and take the second picture.

Double Exposures: Overlapping Images

If your camera lets you make more than one exposure on the same frame of film, you can make flowers glow, ghosts in your living room, and other fantasy effects. Overlapped images, as described here, look different from double exposures against a black background and must be metered differently. With nonoverlapped images, each image is as distinct as if it were a single image; with overlapped images, one image will bleed through the other.

Technical Details

The essential technical thing you must control is exposure. When you make two images that overlap, the film will receive double the amount of light and will be overexposed. You must adjust the exposure so the film receives only half the necessary amount of light each time you release the shutter.

You can do this in a couple of ways: Use manual-exposure mode, take a meter reading, and adjust the shutter speed so it's one-step faster than it should be, or you can adjust the aperture so it's closed down one stop. In

"You can place one image in the center of another..."

other words, if the meter says f/8 at 1/250 sec use either f/11 at 1/250 sec or f/8 at 1/500 sec. Even easier is to fool the meter by doubling the ISO setting for the film. If the film's ISO is 100, set the film-speed dial to ISO 200. Don't forget to reset it when you're through.

"...you can make flowers glow, ghosts in your living room, and other fantasy effects."

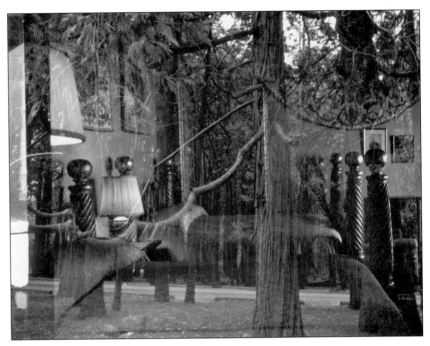

Above: *Shooting a roll of film, then reinserting it in the camera, can produce an unplanned (or planned!) double exposure. Photo by Mano Orel*

 Camera Requirement: Manual exposure control or manual ISO setting, double-exposure capability

Ideas to Try

- Superimpose two different subjects or one subject in different poses. This is the basic double exposure. It's best if one subject is fairly detailed and the other plain. Set the camera for a double exposure, and meter each shot for one stop underexposure.

- Superimpose different-size views of the same or related subjects. Make one shot a wide-angle view and the other a telephoto shot.

- Create a glowing, halo effect. Use a tripod. Focus carefully for the first exposure; throw the lens out of focus for the second. (See page 38)

- Add radiating lines. Use a tripod. Put the main subject in the center of the viewfinder. Make the first shot normally. Use a slow shutter speed and zoom the lens during the second exposure.

- Combine blur and static. Use a tripod. Shoot leaves or plants blowing in the wind. In the first exposure, freeze the motion with a fast shutter speed; in the second, use a slow shutter speed.

- Vary the aperture to change the depth of field. Use a tripod. Make one exposure with a wide aperture and the second with a small aperture.

- Serendipity. Most effects should be well planned, but it's fun to make random double exposures. Shoot a roll of film without planning. You'll waste a lot of film, but you may be surprised with one or two fascinating shots.

Ghost in the Parlor

You can make a haunting image with either a double exposure or with one long exposure. You can even make just a head or hand appear to float around in the room. Make a double-exposure test to see if the film is held motionless between exposures — if it moves even a little bit, you'll get a secondary image of the furniture in the room. Since you don't want that, use any of the methods except method one.

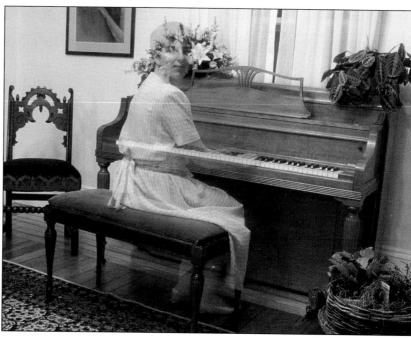

"...be surprised with one or two fascinating shots."

Above: *Ghost in the parlor. Jennifer posed motionless at the piano for five seconds, then left the scene for the rest of the ten-second exposure.*

 Camera Requirement: Bulb or time exposure, double exposure capability

How To Do It

Method One — double-exposure, one location

1. Put your camera on a tripod and be very sure the tripod and camera don't move between exposures.

2. Set the camera to make a double exposure.

3. Set the aperture and shutter speed so each shot will be one stop underexposed.

4. Take a shot of the room, graveyard, or other location without the ghost

5. Make the second shot with your ghostly person.

Method Two — double-exposure, dark and light locations

1. Set the camera to make a double exposure.

2. Meter the scene and set the aperture and shutter speed accordingly.

3. Make the first exposure of the room without your "ghost."

4. Stand your ghost in front of a black background and take a close-up meter reading of the ghost.

5. Take the second shot.

Method Three — just the head or hand

Follow method two, but drape your subject in black so only his head, hand, or whatever is visible.

Method Four — one long, continuous exposure

1. Use slow film and work in a room with dim light.

2. Put your camera on a tripod.

3. Adjust the aperture for a correct exposure with a ten-second shutter speed. You may have to adjust the room light or use a neutral-density filter if the room is too bright for a long exposure.

4. Set the camera for a ten-second exposure, or plan on manually keeping the shutter open with Bulb exposure.

5. Pose the ghost.

6. Start the exposure. After five seconds, tell the ghost to walk quickly out of the scene. During such a long exposure, the ghost's fast movement will not register on film.

Ideas to Try

• Try dressing your ghost in dark as well as light clothes. The darker the clothes, the more transparent they will be. Just make sure the clothing is not the same color as the background, or it will be invisible.

• Make multiple exposures, having the ghost move to two or three different places.

• Have the ghost move very slowly during the exposure, causing streaking lines.

• Add a glow around your ghost by dressing him or her in light colors and using a diffusion filter when you shoot. (See page 30)

• When using method one, you can alter the transparency of the ghost by dividing the exposures unevenly, making sure the total amount of underexposure equals two stops. The more exposure the ghost receives, the more transparent it will be.

• When using methods two and three, alter the transparency of the ghost by underexposing, by one to one and a half stops, the shot of the ghost against the dark background.

"Have the ghost move very slowly during the exposure..."

- Use a color filter over the lens for one or both shots. (See Appendix, page 97, on color theory)

Double Exposures: Color flashing

On page 43, you saw how you can add a second image because heavily shadowed areas have little or no effect on the film. You can use this principal to turn shadows and silhouettes into color shadows and silhouettes with a technique called "color flashing."

Color flashing works on any part of the picture that has some image — the deeper the tones in the scene, the more color you'll add to the image without affecting light areas.

The effect is completely different from one you would get by putting a color filter over your lens. A filter produces color in light areas; color flashing adds color to dark areas. The color intensity depends on the exposure. (See page 40)

 Camera Requirement: Manual exposure and focus control, double-exposure capability

How To Do It

1. Prepare your camera for a double exposure.

2. Meter your subject normally and make the first exposure.

3. Fill the viewfinder with a solid-colored paper, thrown out of focus.

4. Place an 18-percent gray card on top of the color card, and take a meter reading from it.

5. Adjust the exposure as outlined in the Ideas section, and make the second exposure of the color card.

Ideas to Try

- Add an overall color tint to the scene (brown gives a nice, old-fashioned sepia tone): Expose the color card as indicated by the meter reading.

- Turn cast shadows and silhouettes into color ones. Expose the color card according to the meter reading. (See page 40)

- Add a hint of color to the shadowed areas of a subject: Give the color card three stops less exposure than the metered reading.

- Intensify the principle color of the scene or add a bit of color to a gray statue or building: Give the color card two or three stops less exposure than the metered reading.

- Create a colored spotlight effect: Use a color card with a circle of a lighter color in the center. Give the color card two or three stops less exposure than the metered reading.

"...turn shadows and silhouettes into color shadows."

"…look like they were painted by a master Impressionist."

Multiple Exposures

Many cameras let you make multiple exposures, which can produce some exciting effects — images that explode with vitality or look like they were painted by a master Impressionist.

 Camera Requirement: Multiple-exposure capability, manual ISO setting

How To Do It

1. Exposure: You must underexpose each shot so the cumulative total of all the exposures equals the correct exposure. The easiest way to do this is to determine the number of exposures you're going to make, then multiply the film's ISO by that number. For example, for ten shots on ISO 100 film, change the dial to ISO 1000. Remember to set the dial back when you're through!

2. Working with a limited multiple-exposure dial. Many cameras limit the number of exposures. If you want to make additional exposures, set the multiple-exposure control for the maximum number, but make one less shot. Then reset the multiple-exposure control for another series. It's best to do this with the camera on a tripod. With a handheld camera, use an object in the center of your viewfinder as a reference point when you put the camera back up to your eye.

3. Know the limits of the viewing angle. If you'll be moving the camera, rehearse the movement to be sure the subject stays within the frame and no distracting bright spots intrude.

Above: Making about 25 exposures on one frame of film and repositioning the camera slightly between exposures creates Impressionistic pictures.

The Techniques

Random Camera Displacement: the Impressionistic effect

1. Choose a subject with a lot of detail.

2. Make at least fifteen or twenty exposures, changing the camera position a fraction of an inch between each one. If you handhold the camera, your natural body movement will provide just the right amount of camera displacement.

3. Although you'll move the camera between shots, be sure to hold it steady during the exposure.

Vertical Camera Displacement

1. Choose a vertical subject. You can also get great effects with horizontal ones.

2. Put your camera on a tripod and lower the camera an inch or two between shots.

3. Plan on making ten or more exposures.

Horizontal Camera Displacement

1. Choose a horizontal subject. You can also get interesting effects with a vertical subject.

2. Put the camera on a tripod and move it an inch or two horizontally between shots.

3. Plan on making ten or more exposures.

Stepped Zoom

1. Use a zoom lens and put your camera on a tripod.

2. Make ten to twenty exposures on a frame, changing the focal length a little bit between shots.

3. Try to zoom the same amount each time so the steps will be equal.

Masked Zoom Portrait: multiple halo of hair

1. Use a model with a fairly full, curly head of hair

2. Place her in front of a black-velvet background in a darkened room.

3. Use a zoom lens and put your camera on a tripod.

4. Backlight the model's hair and use another light to illuminate her face.

5. Turn off the front light and base your exposure settings on the back-lit hair. You do not have to make any exposure adjustment for overlapped images.

6. Make three exposures, starting at the longest focal length. Change the focal length in fairly large, equal increments between exposures. Use only the backlight.

> "...your natural body movement will provide just the right amount of camera displacement."

7. Do not change the focal length after the third shot. Turn on the front light, reset your exposure, and make the fourth shot. You can use a flash or photolamps.

Static Camera, Moving Subject

1. Your subject can be any moving object or person that will stay within the lens' field of view.

2. Put your camera on a tripod.

3. Thirty or more exposures of a ferris wheel at night are not too many, while fifteen frames of a boat bobbing on water, or six to eight frames of a dancer or athlete in motion are probably sufficient.

Ideas to Try

- In vertical and horizontal displacement, and in step zooming, move the camera in progressively larger or smaller amounts.

- Use color filters on all or some of the shots. Work with three or four colors, repeating them as often as you like. For an exceptionally exciting effect, see Tricolor effects on page 24.

Slide Sandwiches

A slide sandwich is a fast and easy way to make a special-effect photograph — no unusual or expensive accessories needed. It's simply two slides together in one slide mount. You can shoot slides especially for

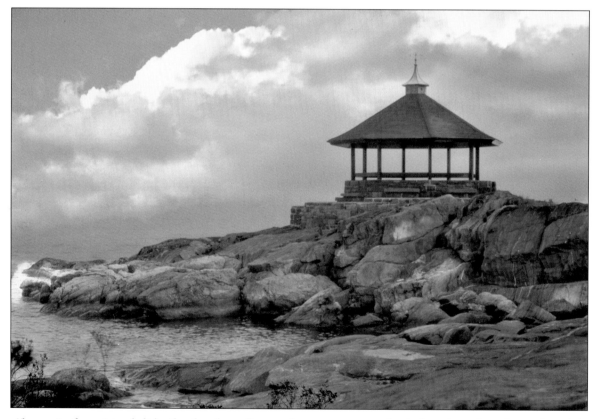

Above: In the original slide, the sky above the gazebo was empty and colorless. I combined it with a slide of fluffy clouds to produce an award-winning photograph.

"...entirely new images that are more interesting than either slide alone."

sandwiching, or you may be able to produce fantastic pictures from slides you were ready to discard. Experiment with various combinations. You may come up with entirely new images that are more interesting than either slide alone.

Technical Details

Sandwiching slides produces the opposite effect of a double-exposure. Subjects that work with one technique usually won't work with the other. For example, if you have a slide showing the moon against a dark sky, you cannot sandwich it with another piece of film. The dark area of the sky would obscure everything on the other picture. You could, however, shoot a picture of the moon and double-expose it with another scene.

If you shot a picture of the sun in the midst of a light-colored cloudy sky, you could not double-expose this with another scene. The whitish sky would have almost completely exposed the film, leaving no more unexposed emulsion to record another image. But if you had a slide of that cloudy sky with the sun, you'd have a wonderful image to sandwich with a landscape that has a clear, uninteresting sky.

Workable Combinations

- Two light or overexposed slides.

- Primary and secondary slides.

 Primary slide: dark subject and light background.

 Secondary slide: light tones and no dominant center of interest.

How To Do It

1. Use a light box or a substitute (See Appendix) to view your potential combinations.

2. Choose slides that bear a relationship to each other and produce a meaningful image, or juxtapose wildly different images for irony.

3. Check that dark details on the two slides don't overlap or intrude, making a confusing image.

4. Clean all four slide surfaces well, using an air blower or antistatic brush. Once the slides are mounted together, any speck of dust will be trapped forever.

5. It's best to place the pieces of film together emulsion to emulsion. This keeps both images in focus when you project them.

6. If you have to mount the slides emulsion side to base side, it's best to put them in a glass slide mount. It will hold them more tightly than open mounts.

7. It's a good idea to rephotograph the slide sandwich so that the camera's depth of field will keep both in focus. Rephotographing them lets you reuse those original slides to see how many other combinations you can create.

"Shoot two images with one in focus, the other out of focus."

Suggestions for Slide Combinations

- *Silhouettes*. A silhouette combines well with a normally exposed slide, providing there are no dark areas that overlap. This is an excellent way to add an interesting foreground to a sunset picture. Make a collection of silhouettes that you can draw on whenever you need to improve a picture.

- *Textures*. These combine exceptionally well with pictures that do not have fine detail. Shoot things like tree bark, cement, burlap, carpeting, snow, and sand. To emphasize the texture, be sure the light strikes the surface from the side.

- *Patterns*. Look for patterns made by bricks, stones, tiles, and wood grain, wallpaper, or a large field of flowers. You can buy books of geometric patterns in art stores.

- *Abstracts*. Use the suggestions in the chapters on abstracts and blur. Colorful subjects shot out of focus and overexposed also make good backgrounds.

- *Color*. When you have a few exposures left on a roll of slide film you want to finish, fill the frame with a solid color, slightly out of focus. Shoot with various exposures to give yourself a range of tones.

- *Identical images*. Shoot the same image twice, both slightly overexposed, then combine them. Here are some suggestions: Reverse them so one is on the left side and the other is on the right. Flip them so one is upside down, the other right-side up. Displace them by a tiny amount, perhaps placing them at a slight angle to each other. Shoot the two images with one in focus, the other out of focus.

- *Title slides*. Print your title, using black letters on a white background, and photograph it. Sandwich the processed slide with an appropriate scene that contrasts with the lettering and is not cluttered in the area where the words will fall. You can sometimes use background slides that are slightly out of focus.

- *Masks*. Buy (or make, if you are a darkroom person) slide masks shaped like a leaf, map, or other easily identifiable shapes. Sandwich a mask with a related picture to introduce variety into a slide show, eliminate an unimportant part of the picture, or cover distracting elements or imperfections.

- *Miscellaneous*. Use pictures of clouds, rainbows, and streaks made with diffraction filters. Take several photographs of the sun on a very hazy day, placing it in different parts of the frame. Do the same with the moon against a pale morning sky.

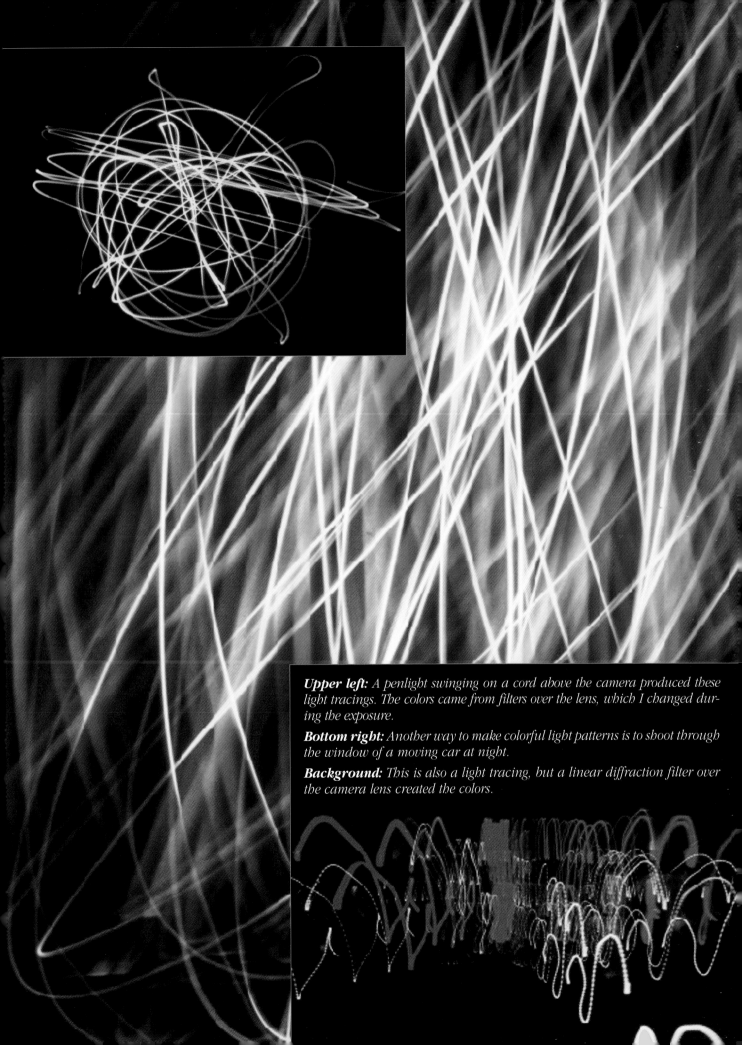

Upper left: *A penlight swinging on a cord above the camera produced these light tracings. The colors came from filters over the lens, which I changed during the exposure.*

Bottom right: *Another way to make colorful light patterns is to shoot through the window of a moving car at night.*

Background: *This is also a light tracing, but a linear diffraction filter over the camera lens created the colors.*

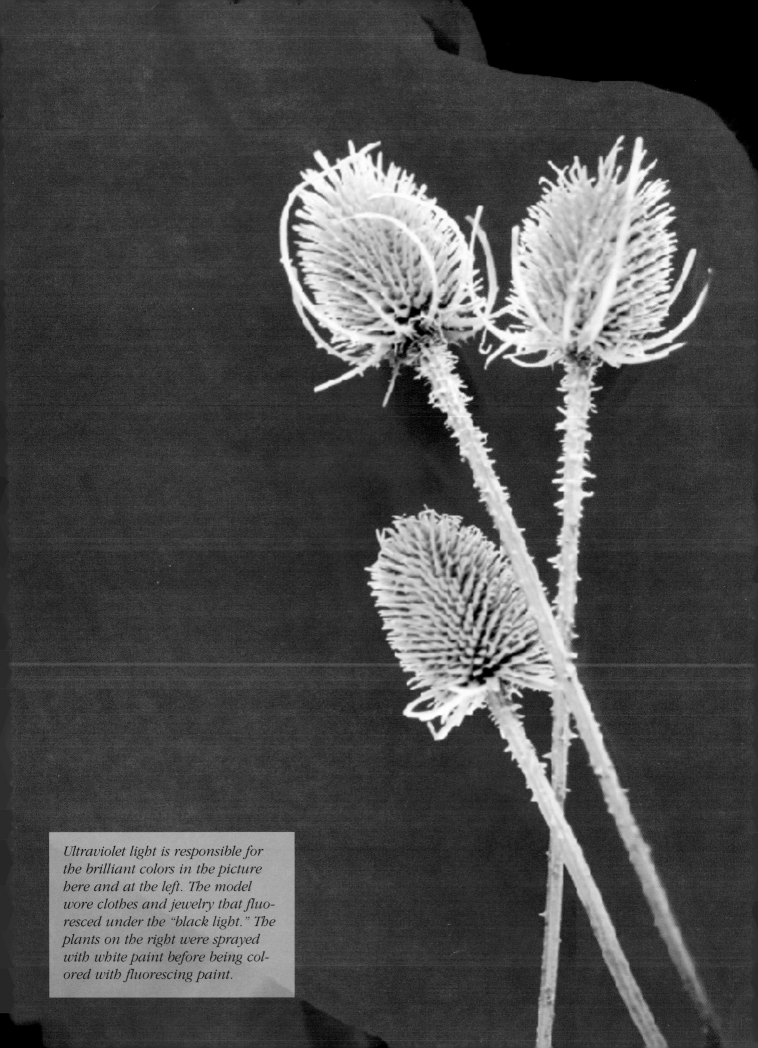

Ultraviolet light is responsible for the brilliant colors in the picture here and at the left. The model wore clothes and jewelry that fluoresced under the "black light." The plants on the right were sprayed with white paint before being colored with fluorescing paint.

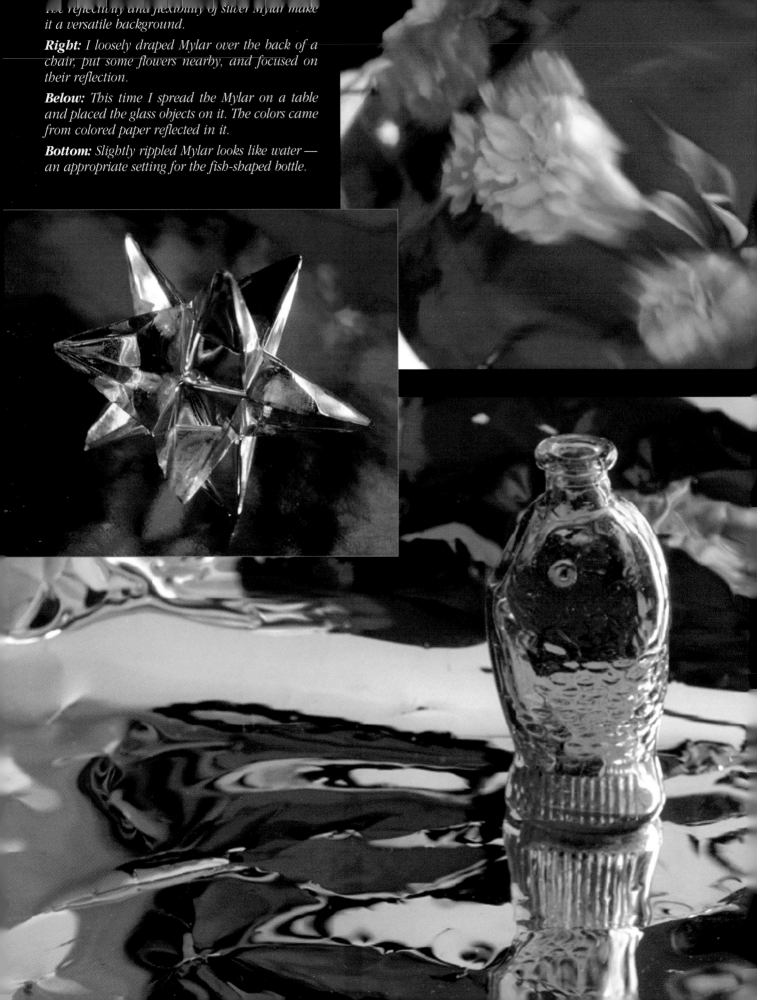

The reflectivity and flexibility of silver Mylar make it a versatile background.

Right: I loosely draped Mylar over the back of a chair, put some flowers nearby, and focused on their reflection.

Below: This time I spread the Mylar on a table and placed the glass objects on it. The colors came from colored paper reflected in it.

Bottom: Slightly rippled Mylar looks like water — an appropriate setting for the fish-shaped bottle.

"...letting the lights themselves be the subject of the photograph."

Each of the three outlines was traced by a penlight covered with a different color acetate during the thirty-second exposure, while Nicholas sat motionless in a darkened room.

CHAPTER FIVE

Lighting Effects

All photographers depend on light to illuminate their subjects. Special-effects photographers use lights in some unusual ways, including letting the lights themselves be the subject of the photograph.

Hot Lights

Hot lights are called that because they get hot. They are also called continuous lights because they can stay on continuously. These include photoflood lights in reflectors, quartz flood lamps, and small video lights.

Coloring the Light Source

Adding color to a light is a basic technique. The source of color is a theatrical gel (color filter) made specifically to withstand the heat of the lamps. The colored acetate in art stores is not heat resistant; don't use them. Even when using theatrical gels, keep them at least six inches from quartz flood lamps.

The effect from one colored light illuminating an entire scene is only slightly different from using a color filter over your lens. The excitement starts when you use two or more lights, each with a different colored gel. The colors of light mix in an entirely different way than do pigments, and the color change that occurs when a colored light falls on a pigment may amaze you. See page 96, the section on color theory in the Appendix.

Ideas to Try

- Use one colored light and one that's unfiltered. Experiment with their placement and intensity.

- Use two lights of different colors. Again, try different angles to make one color predominate, or let the colors overlap and mix.

- Change the relative strengths of the lights by moving one closer to the subject than the other or using lamps of different wattages.

"Gray shadows are dull, but you can turn them red, blue, green..."

Colored Shadows

Gray shadows are dull, but you can turn them red, blue, green, or whatever color you like. You'll be using two lights, an unfiltered light and one with a color gel.

How To Do It

1. Use a white background to show off the effect best.

2. Light the subject with the unfiltered light, positioned so it casts a strong shadow.

3. Place the light with a color gel on the shadow side of the subject and close to the shadow, but not close enough to wash out the shadow.

4. Adjust the intensities and positions of the lights until you see the desired effect.

Moving the Light

What do a pen and a penlight have in common? You can draw or write with them. When the room is dark, you can make a narrow beam of light from a penlight perform like a radiant pen or brush.

Light Writing

It's best to have an assistant to do the writing, although it is not necessary. Practice the writing before you shoot the picture because the words have to be written backwards. And know the limits of the camera's angle of view.

 Camera Requirement: Time or Bulb exposure, aperture control

How To Do It

1. Work in a dark room with a black background, or go outdoors at night. Your assistant should wear dark clothing.

2. The lens aperture depends on the intensity of the light. Do test exposures at different apertures. As a good starting point, try f/5.6 with ISO 200 film.

3. Focus the camera while the lights are on, or use a flashlight to aid you if you're outdoors.

4. Set the camera for a B (Bulb) exposure.

5. Direct the light so it always faces the camera.

6. Start the exposure, then tell your assistant to begin writing. He should turn off the penlight and turn it on again if he writes more than one word.

"Use a Fourth of July sparkler...."

Ideas to Try

- Use a piece of colored acetate over the light bulb to make your lines in color.

- Walk or run with the light to make random swiggles.

- Use a Fourth-of-July sparkler instead of a penlight.

- If you don't have Bulb exposure on your camera, you can use time exposure if you anticipate how much time you'll need for the light writing.

Subject with a Light Drawing

Use your penlight to put a border around a subject, add a halo over a person's head, or put a flower in a flowerpot.

 Camera Requirement: Bulb or time exposure, aperture control

How To Do It

1. You must be able to fire a flash at the end or beginning of a long exposure.

2. If your flash works with aperture priority, set the aperture to f/5.6. Otherwise, use the aperture recommended by the flash for the distance you are shooting from.

3. Work in a dark room and follow the directions for writing with light. When the drawing is finished, fire the flash, and end the exposure.

Ideas to Try

- Draw an outline around your subject with a colored light.

- Change filters and draw a second outline, and maybe a third.

- Give the subject a crown, sunburst, or other adornment.

- Put a simple drawing in a blank area of the picture — a star, moon, smiley face.

Physiograms

Let your penlight swing like a pendulum and it will draw whirling spiral designs for you. The results look complex but the method is not.

Here's the setup: Your camera is on a table or the floor, with the lens facing the ceiling. The penlight is suspended from the ceiling so the bulb is four or five feet directly above the lens. (See page 57)

 Camera Requirement: Bulb or time exposure, manual focus and aperture control

How To Do It

1. You want the flashlight to emit just a point of light. If its reflector spreads the light too much, place black tape over the reflector. Or punch a small hole in black tape and put that over the light.

2. Attach a black cord to the end of the penlight. If the light doesn't have a hook, use tape to secure the cord around it.

3. Tie the cord to a ceiling fixture.

4. Use a 50mm or wider lens to keep the light within the field of view of the lens. With the light four or five feet above the lens, you'll be able to swing the light within a three-foot width.

5. To set the focus, put the camera in place and measure the distance from the light bulb to the film plane.

6. Make sure no stray light can creep in under the door or through the windows.

7. With ISO 100 film, set the aperture to f/8. This F-stop is an approximation, since it depends on the brightness of your light. Shoot a test roll at several different apertures.

8. Set the camera for Bulb exposure or a 20-second time exposure.

9. Switch on the flashlight.

10. Turn off the room lights.

11. Start the pendulum in motion.

12. Open the camera's shutter, preferably by using a cable release.

13. If your camera is on Bulb, end the exposure after about 20 seconds.

Ideas to Try

- Tie a string to the cord holding the penlight. Pull on it to control the direction of the pendulum's swing.

- Experiment with exposure times.

- When the light is moving slowly, the light tracings will be broader and brighter than when it is moving quickly. Try both.

- Hold a large piece of black cardboard in front of the light and change filter colors when you change the light's movement.

- Make a combination of patterns. After recording one pattern, lay a piece of black cardboard on top of the lens, start the pendulum moving in another direction, and remove the cardboard.

- Put a matte box (See page 35) with a shaped mask in front of the lens and use a long exposure time to fill the unmasked areas with squiggles of light. This is especially effective when you change filter colors several times.

- Use color, multi-image, diffraction, and other filters. (See page 21)

"Make sure no stray light can creep in under the door…"

Highway Lights

Your subject is light. Your source of light: tail lights, headlights, street lights, neon lights. Your results: ribbons of red and white, multicolored squiggles, and radiating beams. These are all nighttime shots made with long exposures. Use ISO100 film to prevent your pictures from being overexposed.

 Camera Requirement: Bulb or time exposure, aperture control

How To Do It

1. Streaking taillights: Find a vantage point overlooking a highway where the area is dark and the traffic is moving continuously. Put your camera on a tripod, set the aperture to f/16 or f/22, and make several exposures using shutter speeds from five to thirty seconds.

2. Squiggly highway lights: When you are a passenger in a car at night, point your camera out of any window, set the aperture to f/16 or f/22, set the shutter for a five or ten-second exposure, and press the button. Don't try to hold the camera steady — the more it bumps, the more interesting your picture will be.

3. Radiating neon signs: Set your shutter speed for one second, take a meter reading from a neon sign, and zoom the lens during the exposure. (See page 14)

Black Light

Black light or ultraviolet (UV) radiation is invisible to our eyes, but if you shine it on certain objects, they will reflect visible light, that is, fluoresce. It's this visible light that you can photograph. The colors of fluorescent paints and dyes under UV light are usually quite different from their appearance under white light. (See page 59)

You'll need two UV lamps. The ones to get are those that look like deep blue fluorescent-light tubes and are coded BLB. A 15-watt lamp may fit into an under-cabinet fixture, and you can make it stand vertically if you glue a piece of wood to one end.

You can also buy a complete unit in a reflective fixture. Even with two lamps, it's best to intensify their output by curving a sheet of aluminum foil behind them, or use white cardboard that has fluorescent brighteners as a reflector.

Things that Fluoresce under UV Light

- Many things around the house will surprise you: fabrics, plastics, powdered detergents and white clothes washed in them, cosmetics, petroleum jelly, toothpaste, and your teeth.

- Art-supply and stationery stores have fluorescing gift-wrap yarn, poster board, paper, inks, crayons, chalks, felt markers, pencils, and oil paint in stick form.

"Many things around the house will surprise you: fabrics, plastics, powdered detergents..."

- Fabric companies catering to costume designers sometimes have fabrics, feathers, ribbons, fringe, and sequins.

- Fluorescent makeup, nail polish, and lipstick are available.

- You'll find water-based poster paints for use on cardboard and paper. Lacquer-based paints will adhere to metal, plastic, and fabric. These paints are transparent or semi-opaque, so you must undercoat the object with white paint. You'll also find fluorescent spray paints.

 Camera Requirement: Aperture control

How To Do It

1. Lighter, brighter colors against a matte, black background will photograph best.

2. Place two UV lamps as close as practical to the subject.

3. Load the camera with fast film (ISO 400) and put it on a tripod.

4. Place a yellow 2A or 2B filter over the camera lens. This acts as a barrier to the small amount of bluish ultraviolet radiation the fluorescing object also emits.

5. You want the room very dim with no white light falling on the subject.

6. Using an aperture of f/16, take your meter reading through the camera lens with the yellow filter in place. Come close to the subject so the meter is not influenced by the black background. To play it safe, bracket your exposures.

7. Unless you have brighter lamps than those suggested, limit yourself to still-life setups or closeups of people.

Ideas to Try

- Photograph glassware filled with water and fluorescent watercolor paint, or grate some fluorescent chalk and pour water over it. Make the edges of the glass more visible by accenting them with petroleum jelly or a bit of fluorescent paint.

- Apply fluorescent makeup or petroleum jelly to a person's face for a ghostlike effect. Apply it under the UV light so you can avoid a blotched appearance.

- Instead of a black background, use one of fluorescing cardboard or fabric.

- Use objects of glass as your subject. The edges will reflect the bright colors.

Electronic Flash

Many effects with flash are also possible with hot lights, but using electronic flash can produce effects that are possible in no other way.

> "You want the room very dim with no white light falling on the subject."

"Some flash units even come with colored filters."

Coloring the Light

You need a small piece of colored acetate taped over your flash to add color to the light. Some flash units even come with colored filters.

Look at the section on colored light on page 61. You can achieve similar results with flash. If you want to use more than one flash unit with different color filters, you'll need a slave attachment or a flash with a built-in slave. The slave enables a second flash to fire when the first one is activated.

Sharp Plus Blur

You can add streaky lines behind a moving subject by using flash plus hot lights when you make the photograph. The hot lights can even be ordinary room lights.

 Camera Requirement: Bulb or time exposure, manual exposure control

How To Do It

1. Hang up a black background.

2. Set up the lights, load the camera with slow film, and put the camera on a tripod.

3. Have the model rehearse the movement so he or she stays within the viewfinder from start to finish.

4. Set your camera for a time exposure, based on the length of time of the action, or set it for Bulb exposure.

5. Take a meter reading and set your camera's aperture for one stop underexposure (smaller F-stop). You may have to make the light dimmer by moving it farther away or by using a neutral-density filter.

6. Set the flash for manual exposure, based on the flash-to-subject distance.

7. Adjust your lighting so both the ambient lighting and flash both require the same F-stop.

8. Start the model's action.

9. Open the shutter.

10. Fire the flash by one of these methods:

 • _Open flash_ — the flash is off the camera, and you fire it manually with the test button while the shutter is open.

 • _Rear-curtain synch_ — the flash fires automatically at the end of the exposure.

 • _Front-curtain synch_ — the flash fires at the start of the exposure. This makes the blurred trails seem to go the wrong way. If this is your only option, have the person walk backwards. (Be sure to rehearse well!)

Ideas to Try

- Handhold the camera so you deliberately blur the background.

- Experiment with shutter speeds from 1/15 sec to five seconds.

- Use flash outdoors in early evening or other time when it is not too light.

Stroboscopic Effect

A true stroboscopic lamp fires many short pulses in one second. Several advanced flash units do something similar by emitting a succession of short bursts. The effect on the photo is many overlapping images of a subject in motion. You can simulate the effect with an ordinary flash if it has an open-flash (test) button.

 Camera Requirement: Bulb or time exposure, manual exposure control

How To Do It

1. Work in a room you can darken completely, and set up a black back-ground. You can also work outdoors on a dark night.

2. Put your camera on a tripod.

3. Have the model rehearse the movement so the subject stays within the viewfinder from start to finish.

4. Set the flash for manual exposure, based on the flash-to-subject distance.

5. Set your camera's aperture for one stop underexposure (smaller F-stop) than the necessary aperture for the flash. This will compensate for overlapping images.

6. Place the flash where it will illuminate the subject, but do not connect it to the camera.

7. Position the subject and set your focus.

8. Turn off the room lights.

9. Open the shutter on B or Time.

10. Have the subject start moving, parallel to the camera, not toward or away from it, at moderate speed. Fire the flash repeatedly as rapidly as it recycles.

"The effect on the photo is many overlapping images of a subject in motion."

Chapter Six

Projection Effects

A slide projector can let you create unusual effects or make it easy to do some of the special effects described in other chapters.

There are two types of projection: front and rear.

In front projection, the projector and camera are on the same side of the screen. The camera lens and projector lens must be as close to each other as possible to avoid distortion.

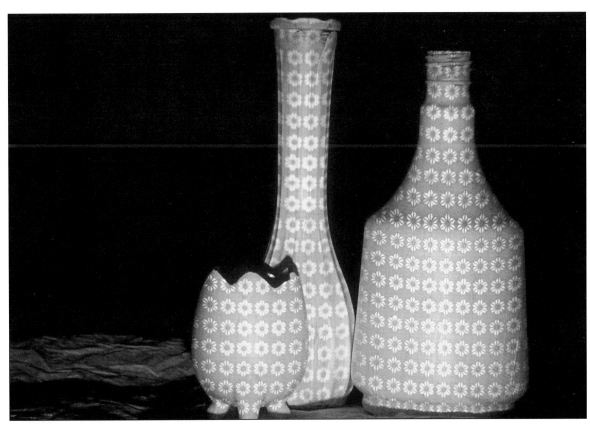

Above: *Surprise! These vases are actually white. The flowers came from a slide projected onto them as they stood in front of a black velvet background.*

Tweed fabric pinned to cardboard made an appropriate projection surface for this picture of a barn.

By Front Projection

How To Do It

1. Choose a textured material that is white, off-white, or beige.

2. Mount the material onto a firm surface, about 16 x 20-inches or larger, pulling it taut and fastening it with pushpins.

3. Place the screen so it faces the projector.

4. Mount the camera on a tripod, placed to minimize image distortion.

5. Work in a darkened room, where light does not fall across the screen.

Projection Surfaces — Some Suggestions

- Burlap, linen, silk, towel, canvas, lace, textured wallpaper, wrinkled paper, raw silk.

- Instead of a screen, project on cork, stone, brick, weathered wood, or ceiling tile.

- Project on a window (at night) on which drops of condensation have formed.

By Rear Projection

With Textured Papers

Browse in art stores for rice paper, tissue paper, and other translucent papers that have texture. Use them for a rear-projection screen.

With Textured Glass

The effect is similar to photographing a subject behind textured glass (See page 88), but the rear-projection setup gives you a never-ending selection of subjects you can shoot.

 Camera Requirement: Manual focus control

How To Do It

1. Get a sheet of textured glass or plastic about the size of your rear-projection screen. Coarse, irregular patterns are best.

2. Set up the rear-projection screen.

3. Stand the textured plastic upright, on the camera side of the screen. The closer the plastic is to the screen, the less distortion, so try different distances.

4. Focus on the textured plastic and take your meter reading from it.

 Camera Requirement: Aperture control

How To Do It

1. Set up the projector in a darkened room, where it is the only source of light.

2. Keep the subject far enough from the background (a black one is best) so the projected image doesn't fall on the background, or position the projector at an angle to the subject.

3. Load your camera with fast film and put it on a tripod.

4. Come close to the subject to take a meter reading.

5. Take the picture.

Texturized Pictures

"You'll want the texture and image to complement each other."

By projecting slides on a textured material and rephotographing them, your photographs can take on the texture of the material. You'll want the texture and image to complement each other.

For example, a picture of a weather-beaten building would be appropriate with burlap, or a portrait of a woman would be well suited to silk. Choose slides with large, colorful subjects, and without fine details that would be obscured by the texture. You can use either front or rear projection.

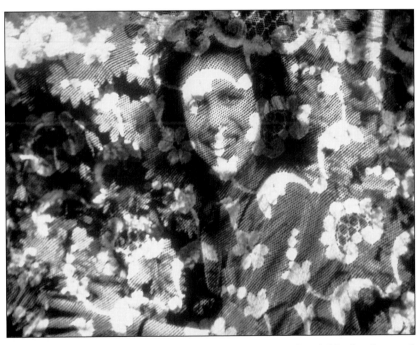

Above: Here I propped up a piece of cardboard covered with black velvet and a white lace scarf. I projected the portrait onto the lace and rephotographed it.

71

In rear projection, the projector and camera are on opposite sides of a special screen, so there's no difficulty in aligning the two lenses. The image projected on one side of this screen is also visible on the other side.

You can buy rear-projection screens at many camera stores, or you can make a good substitute by tacking a piece of frosted acetate or tracing paper to a frame. Place the slides backwards in the projector so they will be properly oriented when you photograph them from the opposite side of the screen.

The Projector as a Light Source

Special-effects photographers are not limited by the traditional ways of doing things. Most photographers use a projector to show slides on a screen. Special-effects photographers can project images onto other subjects, rephotograph them, and come up with some incredible pictures.

You'll need to shoot special photographs on slide film for this effect. White or light-colored subjects, especially the nude body, make the best projection surfaces.

Effects You Can Create

- Turn white subjects into colored ones. Project solid-color slides onto light-colored objects, or mount colored gels in slide mounts.

- Turn white subjects into multicolored ones. Project a slide of a multicolored scene, throwing it out of focus.

- Cover your subject with patterns. Photograph dots, stripes, checks, and other patterns in either black-and-white or color. You can buy books of black-and-white patterns in art-supply stores. See page 99 for other sources.

- Cover your subject with texture. Photograph tree bark, grass, bricks, or other clusters of small things.

- Cover your subject with words and graphics. Photograph black-on-white words, music, numbers, and other symbols that have some relationship to the subject.

- Embellish the subject with abstract images. Follow the suggestions in the chapter on Abstracts (see page 88) and shoot them on slide film.

- Add pictures. Photograph clouds, autumn leaves, or other simple subjects.

- Throw a shaped spotlight. Take a 2 x 2-inch piece of thin, rigid black plastic or cardboard and cut a simple shape into it. Or find a picture of the shape you want, trace it onto white paper, and blacken the area surrounding the shape. Photograph it twice, with your camera on a tripod. Mount the identical slides in a single slide mount. One slide alone will not be dense enough; two will work. Add color if you wish.

"You'll need to shoot special photographs on slide film for this effect."

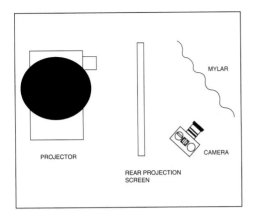

With A Reflected Image

How To Do It

1. Use a sheet of silver Mylar, somewhat larger than your rear-projection screen.

2. Fasten the Mylar to a sheet of self-adhesive foam board that has a bumpy surface. Or staple the Mylar to a board, but only at the top, so it hangs in loose folds and ripples.

3. Stand the Mylar upright, behind the screen and at a slight angle.

4. Place the tripod-mounted camera so it faces the Mylar squarely.

5. Focus on the reflections. Why not project directly onto Mylar? Because you would get extremely glaring highlights.

Double-Exposure Effect

The effects you create with two projectors are similar to those made with a double exposure (see page 43), but your camera does not have to have double-exposure capability. There are other advantages to doing it by projection: You don't have to guess at what the result will be — you can see it before you shoot.

You can shoot specifically for making combination pictures and do it whenever it's convenient. You can calculate the exposure easily. These should be enough reasons to run out and buy — or borrow — a couple of projectors.

Above: *I put the moon in the picture by using two projectors: one with a slide of the building, the other with the moon — focused on one screen. Then I rephotographed the combination. It's a great way to combine images without making a double exposure.*

How To Do It

1. You can use either front or rear projection.

2. Bear in mind that dark areas on one slide are where the other image will come through; a light-colored area will lighten the other image.

3. The projectors should have lenses of identical focal lengths.

4. Place the two projectors close together to avoid distortion.

5. With front projection, put the camera on a tripod behind and slightly above the projectors. You want the axes of all three lenses to be as close together as possible.

6. Set up a screen that has a smooth, untextured surface.

7. Align the images so their borders coincide.

8. Turn off the room lights and take a meter reading from the screen.

9. If the image from one projector is too bright, tape a neutral-density filter in front of the lens.

Ideas to Try

- Experiment with many combinations, even if they seem wild. Try an abstract picture with a realistic one.

- Use colored or special-effects filters in front of the camera lens.

- Create a picture within a picture by using masks. Put a slide with a mask in each projector. One mask should be clear with a black circle or other shape, the other is black with an identical clear shape. This produces the same effect as using double masks described on page 47, but it's easier to align the masks.

Creative Geography

Wouldn't it be fun to be in your own living room on a snowy day and photograph someone standing in front of palm trees? With the magic of the projected image, you can. Project the background on a screen and put your subject in front of it. You can use front or rear projection.

- Work in a fairly dark room, making sure no light falls on the screen except that from the projector.

- Light the subject with photoflood lamps or flash. The direction of this light should appear logical in relation to the background image.

- Lighting on the subject should be as bright or somewhat brighter than the background.

- The projected image should show only one distance plane. Your subject provides the foreground.

- Some excellent images for background slides are sunsets, foliage, distant landscapes, mountains, stone walls, building exteriors or interiors, and abstracts.

"Experiment with many combinations, even if they seem wild."

"This basket of fruit was not in a lovely mountain setting...."

Above: This basket of fruit was not in a lovely mountain setting, it was on my dining room table and the background scene was rear-projected behind it.

By Front Projection

Stand a model in front of a screen, put a scenic slide in the projector, project the slide as a background, and take the picture. Yes, you will also get the scene projected on the person's body and a shadow falling on the screen. There is a way to avoid these problems. Place the projector at an angle to the screen so the light does not fall on the model. The background will be somewhat distorted and part of it will not be sharp, but this might not be objectionable. It may even add a sense of depth.

Rear Projection

Rear projection usually avoids the problem of the projected image falling on the subject or the subject casting a shadow on the screen. You do need a larger room to work in; otherwise reserve rear projection for still lifes and small objects. Because the screen diffuses the image slightly, choose slides that are a bit contrasty, with large colorful areas but little fine detail.

Ideas to Try

- Let the subject be silhouetted against the background.

- Add texture by projecting on a translucent textured paper.

- Tack tracing paper over a window frame and use it as your screen.

- Lay a mirror under the screen on the camera side, so you can photograph the screen image and its reflection.

- Use black or dark blue cardboard for your screen and poke holes in it. Photograph the setup with a star filter over the camera lens.

CHAPTER SEVEN

Reflections

"...take advantage of all sorts of unusual reflecting surfaces."

You've probably shot pictures with the landscape reflected in a lake or made a self-portrait in the bedroom mirror, but special-effects reflections take advantage of all sorts of unusual reflecting surfaces. There's one golden rule in photographing reflections: focus on the reflection itself, not on the reflecting surface. And oh, yes, clean the surface before you shoot into it.

Mirror Reflections

Mirrors on the wall are only a starting place. Look for other reflective surfaces — glass-surfaced modern buildings, sunglasses, wet streets at night, objects painted with glossy black paint.

Look for curved surfaces that will distort the subject. You could go to extremes and use a fun-house mirror, but you can make crazy images in the curved edge of a Christmas-tree ornament, shiny toaster, silver pitcher, foil balloons, chrome motorcycle parts. The list is endless.

Ideas to Try

- Photograph just the reflection.

- Photograph the reflection including the mirror's frame.

- Photograph the subject and its reflection.

- Hang a mirror on a tree, or place one or more mirrors on the ground so they are framed by grass or flowers. Include both the reflection and the surroundings in the photo.

- Avoid your own reflection. Stand where you can shoot into the reflecting surface at an angle. With curved surfaces, a telephoto lens helps.

- Keep both the mirror frame and the reflection in focus. Use a small aperture and have the subject relatively close to the mirror.

- Keep both the subject and the reflection in focus. Use a small aperture and focus midway between them.

- Throw the subject out of focus but keep the reflection sharp. Use a large aperture and focus on the reflection.

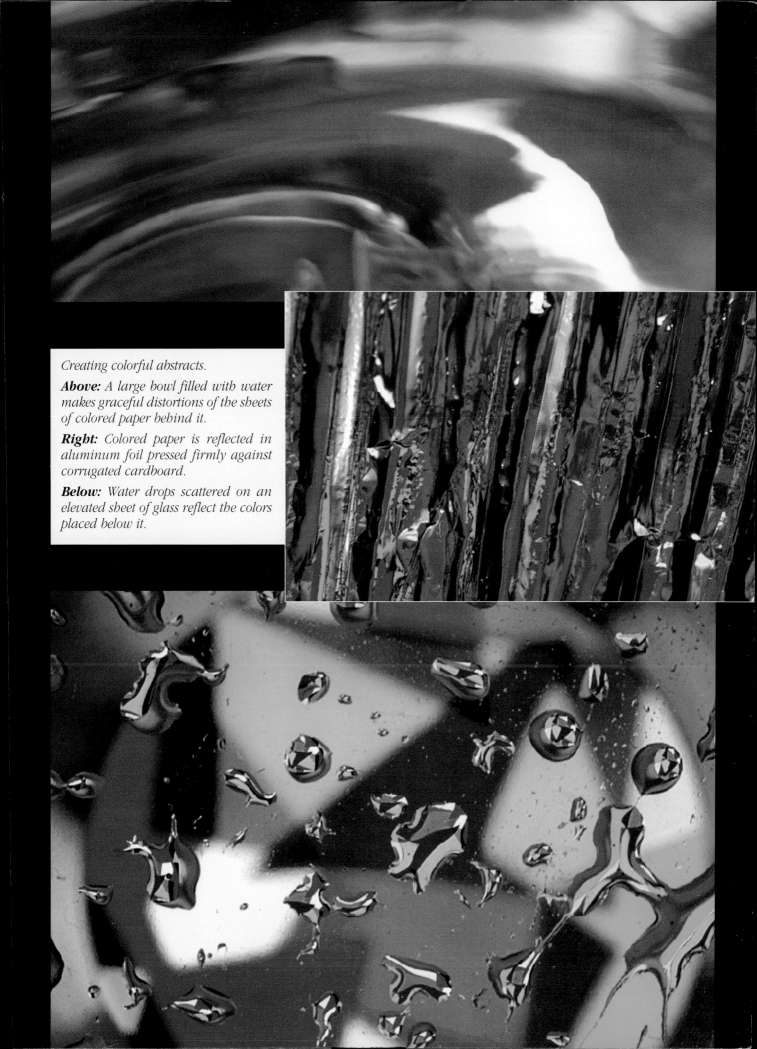

Creating colorful abstracts.

Above: *A large bowl filled with water makes graceful distortions of the sheets of colored paper behind it.*

Right: *Colored paper is reflected in aluminum foil pressed firmly against corrugated cardboard.*

Below: *Water drops scattered on an elevated sheet of glass reflect the colors placed below it.*

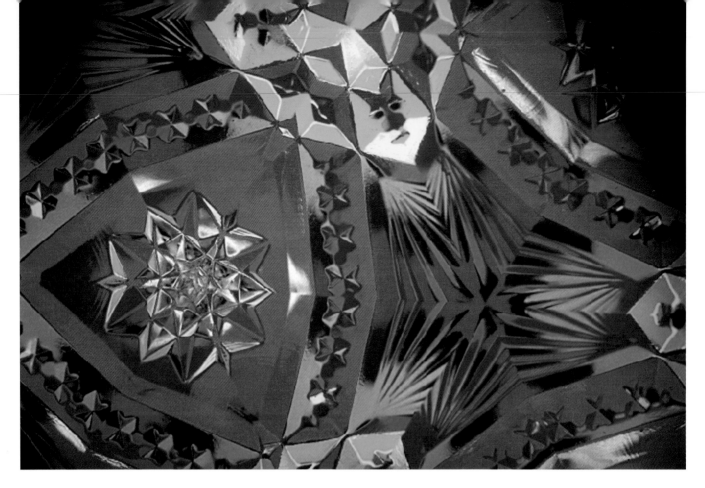

Above: *Great grandma's cut glass bowl gets a new look. With a colorful scarf a distance behind it, the facets produce colorful patterns.*

Below: *A birefringent substance, like this plastic box, turns from clear to colorful when polarizing material is placed above and below it.*

You're never too old to enjoy the iridescent colors of soap bubbles.

Above: *A black background shows off the colors created in a bowl of soapy water.*

Below: *Dip a frame into a soapy mixture and you'll get a thin soap film with changing colors.*

Above: *Drops of food coloring falling into a bowl of water created these lovely, wispy colors.*

Right: *This was a slide of an ordinary-looking flower, but I projected it on a screen placed at an angle to the projector; then I rephotographed it.*

Below: *You can make your own colorful crystals to photograph by painting a thin coat of crystalizing liquid on a sheet of glass.*

- Shoot your own reflection. To prevent your camera from hiding your face, use a wide-angle lens and lower your camera to about chin level, or hold it slightly to the side.

- Shoot a building with many windows, catching the reflections of neon signs or of another building.

- On curved surfaces, use a small aperture to keep all the reflections in focus.

- Deliberately limit your depth of field by experimenting with larger apertures.

- Create a reflecting "pond" with a reflection in the roof of your car.

- Instead of a mirror, place your subject on or in front of a sheet of colored Plexiglas.

- Turn your reflection into a mosaic by using a shattered mirror. Cover the back of the mirror with adhesive tape, wrap it in a towel, and give it one or two taps with a hammer. The tape will hold the pieces together so you can handle it easily, even twisting and bending it.

"Turn your reflection into a mosaic by using a shattered mirror."

Above: *When my daughter, Jan, didn't want her picture taken, I did the next best thing and shot her reflection in her husband Jim's sunglasses.*

Instant Reflecting Pond

An ideal landscape might be one with a snow-capped mountain coupled with its reflection in a lake. But what if there's no lake? No problem. All you need is a small, frameless mirror, about 3 x 3 inches in size, and preferably front silvered. Cokin makes a "Mirage" attachment, which produces the same effect.

How To Do It

1. Use a lens focal length between 35mm and 50mm.

2. Hold the mirror so one edge is near the lower part of the lens and as close as possible to it.

3. Slowly tilt the front edge of the mirror until you see the reflection you like, and take the picture.

Teleidoscope and Kaleidoscope-Like Devices

A kaleidoscope produces its symmetrical patterns by reflecting the bits of colored glass and other objects that are inside it. A teleidoscope, though, is open ended and has nothing inside; the designs you see are multiple reflections of the real world. Instead of making a pattern of pie-shaped wedges, a three-sided teleidoscope produces a triangular-shaped central image surrounded by triangular reflections. You can buy one that's specifically made to screw onto a camera lens. You can also buy a less expensive lens attachment: a short tube with six, twelve, or more mirrored sides. Teleidoscope attachments work best with moderate telephoto lenses in the 100mm to 135mm range. Otherwise, you may get some vignetting, which is not necessarily bad. Small apertures are best since they keep the reflections sharp.

Put a teleidoscope attachment on your lens to create designs and patterns of anything in front of your camera.

Reflections in Mylar

Silver Mylar, a thin polyester film you can buy in an art-supply store, has a wonderful reflecting surface. It's smooth, shiny, and can be draped, rippled, or held flat. Keep it taut and it's almost a perfect mirror. Loosen it so it drapes softly, and you'll get varying degrees of distortion. You can buy Mylar with an adhesive backing. Place it on a rigid surface or a sheet of lightweight plastic that you can bend into convex or concave shapes. (See page 60)

How To Do It

1. Place the Mylar at a 45-degree angle to the subject so that it reflects the image toward the camera and prevents your own reflection.

2. Use a small aperture to keep the angled image in focus.

3. Work in a fairly dark room, lighting the subject with a flood light.

Camera Requirement: Aperture control

Ideas to Try

- Tilt the Mylar way up to include the sky as a background.

- Drape black velvet, colored fabric, or more Mylar behind the subject.

- Spread the Mylar on the table, place an object on it, and photograph the object and its reflection. It will look like your subject is surrounded by water.

- Spread the Mylar on the floor and have a model sit on it.

- See Abstract Images (page 90) for other ways to use Mylar.

Reflecting Tube

Mylar rolled into a tube makes a front-of-the-lens device that can surround a subject with a swirl of fascinating reflections.

 Camera Requirement: Manual exposure control

How To Do It

1. Cut a piece of Mylar about six inches long and wide enough to wrap around your lens. You can also use aluminum foil, but it's not as reflective.

2. Roll it into a tube and secure it with tape or a rubber band.

3. Use a lens about 35mm to 50mm with the six-inch tube. You can use a longer lens, but then you'll need a longer tube, which is harder to manage.

4. Fill most of the viewfinder with a colorful subject.

Ideas to Try

- Bend or squeeze the tube to distort the image.

- Roll the Mylar like a cone, with the narrow end away from the lens.

- Make the tube out of colored Mylar or a textured reflective surface, or line it with colored transparent acetate.

Reflections in Glass

Reflections in glass are usually annoying to photographers, but you can use them creatively to make vibrant images and unusual superimpositions. Strong reflections depend on one thing: the difference in brightness between the subject in front of the glass and the area behind the glass.

Pseudo Double Exposures

The most interesting use of reflections in glass makes what appears to be a double exposure, but you do it with just one click of the shutter.

How To Do It

1. Search for subjects in front of and behind the glass that have an interesting relationship to each other. Look for things that are complementary, contrary, or humorous.

2. If you are shooting a brightly lit store window, position yourself so a reflected subject falls against a dark area.

3. If you want to avoid shooting your own reflection, stand at an angle to the glass, or squat and shoot up.

"...use them creatively to make vibrant images and unusual superimpositions."

4. If much of the area is dark, take your meter reading from the subject that is most important — it may be the reflection or the real subject.

5. Use an aperture small enough to give you sufficient depth of field.

Ideas to Try

- Shoot from inside a restaurant or other room.

- Open your car door and shoot through the window, superimposing the scene in front with the one in back.

- You'll need a tripod and help for this. Stand near a glass door or revolving glass door, but focus on the scene beyond the door. Set a slow shutter speed. Have a friend give the door a push. The picture will show the static scene plus streaks produced by the moving glass.

- Go outdoors with a large sheet of glass (beveled so you don't cut yourself). Pose a model in front of it, catching her reflections. It may be necessary to use a flash so the model is brighter than the rest of the scene.

"The secret of capturing an image in a glass of water..."

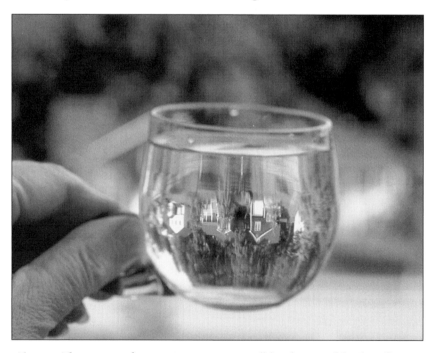

Above: *The secret of capturing an image (like this neighborhood) in a glass of water is to use a glass with a spherical shape.*

Reflections in Water

You may think you know all about shooting reflections in a body of water, but check out these ideas.

Ideas to Try

- Instead of a landscape and its reflection in a lake, photograph only the reflection. Display the picture either right-side up or upside down.

- Throw a rock into a mirror-smooth lake to make radiating ripples.

- Wait for a windy day and let the turbulence turn the reflections into abstract patterns.

- Come close and photograph only a small section of the water.

- Use filters to enhance the image, especially with more turbulent water.

- Take a wine glass that is rounded and bowl shaped, and fill it with water. The curved glass acts as a lens, and you will see upside-down reflections of the surroundings.

Above: *Reflections in mirror-still water can be beautiful, but those in rippling water take on an abstract, painting-like quality.*

Reflections in Drops of Water

"Drops of water can act as little lenses…"

Drops of water can act as little lenses, capturing tiny, inverted images. For these effects, you'll need a macro lens or other close-up equipment to give you high magnification.

Use an aperture of about f/16 or smaller, and since this means a slow shutter speed, use fast film, put your camera on a tripod, and use a cable release or the self-timer to trip the shutter.

On a Branch

A reflection in a drop of water hanging from a branch makes a spectacular photograph, but searching for the right drop in the right position with the right subject reflected can be a frustrating experience.

 Camera Requirement: Manual control of aperture and focus

How To Do It

1. Find a small branch, flower, twig with a bud or berry, or other appropriate natural subject.

2. Bring it indoors and stand it in a piece of modeling clay or support it with a clamp. If you push the clay into a small box or bottle, you can position the twig easily.

3. Choose a subject to be reflected in the water. It's even easier if you use a photograph of an object.

4. Place the subject behind the twig. Turn it upside down if you want its reflection to be right-side up.

5. You'll need a lot of light on the subject to be reflected.

6. Use an eye dropper to carefully place a drop or two of water on the twig. Even better, use white corn syrup instead of water — it adheres better and holds its shape for a long time.

7. Adjust the position of the twig, the subject, and the camera. Focus the lens on the reflection and take the picture.

"...drops reflect their surroundings and provide a great subject for your camera."

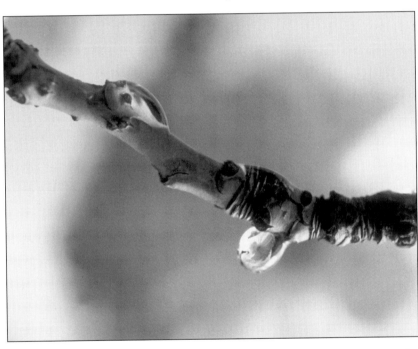

Above: *A drop of corn syrup acted as a lens and captured the image of a nearby flower.*

On a Window Screen

You may have noticed how water droplets cling between the mesh openings of a window screen after it rains. All those little drops can act as micro lenses, reflecting their surroundings and providing a great subject for your camera.

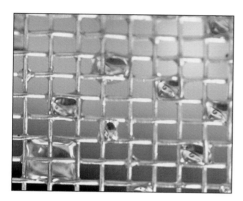

A piece of window screen can trap drops of water and the images behind them.

How To Do It

1. Work in a cool, dry room so the water does not evaporate.

2. Use a piece of window screen, approximately six-inches square. You may want to staple it to a cardboard frame.

3. Fill a spray bottle with a mixture of about one teaspoon of glycerine (available in a drug store) in a quart of cool water.

4. Spray the screen until many holes fill with water. Some drops may span more than one hole.

5. Stand the screen on a table, bracing it with books or blocks and making sure it's parallel to the camera's lens. Or make a support, as described in the Appendix.

6. Place an object or a large photograph about 18 inches behind and parallel to the screen.

7. Carefully focus on the reflections and take the photograph.

On a Glass Surface

If you scatter drops of water on a sheet of glass or plastic, those drops can reflect objects underneath them and you can make some intriguing photos. Here's how:

1. Elevate the sheet of glass or plastic several inches above a table. If you're going to image a transparent subject, you'll need to place it above a light box or substitute (See Appendix).

2. Carefully place small drops of water on the upper glass.

3. Put the object to be reflected on top of the light box, under the water drops.

4. Place your camera above the setup, adjusting the position to include as many drops as you like.

5. Focus on the reflections and take the picture.

Ideas to Try

- Instead of using drops of water, use drops of corn syrup or clear marbles.

- Make puddles of color. Randomly put down globs of white corn syrup on the light box, letting the thick syrup assume amorphous shapes. Instead of pictures or objects underneath, use bits and pieces of transparent colored acetate or cellophane. (See page 77)

"Instead of using drops of water, use drops of corn syrup..."

CHAPTER EIGHT

Abstract Images

"Great photographs don't always need to show tack-sharp images."

Great photographs don't always need to show tack-sharp images. Brightly hued patterns, pastel nebulous shapes, or subjects abstracted into mere suggestions of the real thing are an unending way to be creative.

Impressionistic Pictures

You can create pictures that look like those of the Impressionist masters, even if you can't paint. If your shower has a textured-glass door, you have the one necessary accessory. If not, buy a sheet of textured, embossed, patterned, or frosted glass or plastic. You can even use glass fogged by steam or covered with frost. The size, obviously, depends on the size of the subject.

 Camera Requirement: Manual focus

How To Do It

1. Select subjects with fairly simple, identifiable shapes.

2. You and your camera go on one side of the glass, the subject on the other.

3. Place the subject fairly close to the glass but not touching it. The closer the subject is to the glass, the more recognizable it will be.

4. Focus on the image formed on the glass, not on the subject behind it.

5. If you see reflections on the camera-side of the glass, turn off the lights on the camera side. If you see the reflection of the camera, reposition the camera so it's at a slight angle to the glass.

Ideas to Try

- Experiment with different subject-to-glass distances.

- Use a small aperture to keep both the glass and the subject in focus, or use a large aperture and focus on either the subject or the glass.

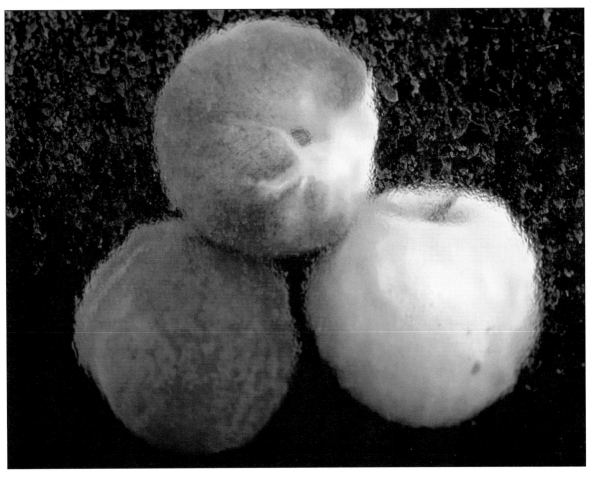

Above: The fruit for this shot was placed behind a textured glass shower door.

- Make your own textured glass by:

 Coating a plain sheet of glass with hair spray, petroleum jelly, clear nail polish, etc.

 Covering it with dots of black or colored ink or paint.

 Chilling the glass in the freezer; condensation will form when you bring it into the warm room.

- Use this technique to rephotograph a print or a slide. Use a finely textured glass so it doesn't overwhelm the subject, and elevate the glass just a bit above the picture.

- Wipe oil on a sheet of plain glass, then spray it with water so that it is evenly covered with small beads of water. Elevate this over a small subject or a print.

- Place boldly textured glass behind glass objects. Focus on the subjects.

Optical Distortion

Take an ordinary drinking glass from the shelf and place it in front of your camera lens. The distorted images are quite fascinating.

 Camera Requirement: Manual focus

How To Do It

1. Choose a subject with strong, bright colors.

2. Choose a glass without an embossed name or logo on the bottom.

3. Put the open end of the glass closest to the lens, but also try it the other way.

4. The closer the subject, the less the distortion.

5. Focus manually, with the glass over the lens; the distortion will drive an automatic focusing system crazy. You'll probably want the scene to be as sharp as possible, although it doesn't have to be.

6. For pure abstraction, create a colorful background of colored paper, metallic board, fabric, streamers, or stacked rolls of cellophane.

Other Optical Distortions

- All types of drinking glasses — long ones and short ones, even colored ones.

- Glass building block.

- Small, thin fishbowl filled with water, with a multicolored background behind it. Swirl the water to make a long exposure. (See page 77)

- Bent and distorted glass and plastic.

Reflections in Mylar and Foil

The chapter on reflections (page 82) tells how to use Mylar to reflect a slightly distorted image. You can also use silver Mylar to break the image up into a complete abstraction or into areas of pure color.

 Camera Requirement: Aperture control

How To Do It

1. Loosely attach Mylar to a sheet of cardboard. A piece about 16 x 20 inches is sufficient for tabletop subjects. Bend, twist, or crease the Mylar to increase the distortion.

2. Position the Mylar at an angle to the subject, so it reflects the image toward the camera.

3. Use a small aperture to keep the image in focus.

4. It's best to work in a dark room, lighting the subject with a flood light.

> "...break the image up into a complete abstraction or into areas of pure color."

Ideas to Try

- To make abstractions of colors, tape pieces of paper in various colors, shapes, and sizes to a sheet of cardboard.

- Increase the distortion by moving the subject farther from the Mylar or by using a large aperture.

- Vary the image by changing the camera angle, the shape of the Mylar, or the point of focus.

- Bracket your exposures to achieve different intensities of color.

- Work in a windy area (or use a fan), use a relatively slow shutter speed (half second) and let the wind ripple the Mylar while you shoot.

- Glue the Mylar to a pebbly textured board, self-adhesive board, or use textured Mylar.

- Use aluminum foil, shiny-side out, instead of Mylar. Crinkle it slightly, smooth it out, and attach it to cardboard.

- For a fascinating texture, use metallic corrugated paper. If you can't find an art store that sells it, simply take aluminum foil, press it firmly against a piece of corrugated cardboard until it conforms to the ridges, and staple it in place.

- Instead of colored paper, use pieces of colored acetate or cellophane taped to a window or placed on a light box. You can tape the pieces together, quilt style, and place it between the light and the Mylar.

- Make a tube or cone out of Mylar, foil, or corrugated foil, and place it around a macro lens. Tape pieces of colored acetate to a window. Move the camera and tube around to gather reflections. Focus on the reflections in the foil, pushing and molding the tube to get different shapes.

- Make a tube as above, but place a similar piece of Mylar or foil at the open end, leaving just enough space between it and the tube so that light can illuminate it.

Cut-Glass Designs

Bring out your treasured cut glass for this. You can substitute pressed glass or even plastic that looks like cut glass. You can use either a horizontal or vertical setup.(See page 78)

Horizontal Setup

Use a light box or a substitute (See Appendix), and something to elevate the glass, such as a coffee can with both ends removed. Arrange pieces of acetate in several colors on the light box, then put the elevated cut glass over it. Photograph the design from above, focusing on the glass.

"Bring out your treasured cut glass for this."

Vertical Setup

Support the cut glass so it stands vertically on a table. Put a large sheet of cardboard as a background about 18 inches behind the glass, and illuminate it with one or two lights. Lay pieces of colored papers, fabric, and/or foil against the background. Some black paper will add definition to the patterns.

Ideas to Try

- Vary the distance of the cut glass to the colors behind it.

- Put objects, magazine covers, and other colorful materials behind the glass.

- Photograph both large and small areas of the design.

- Instead of using either setup, shoot colored lights through the cut glass.

Frost and Ice Crystals

When winter ices up the windows in your house and car, grab your camera before you grab the ice scraper. Keep the lens absolutely parallel to the glass so the picture will be sharp all over.

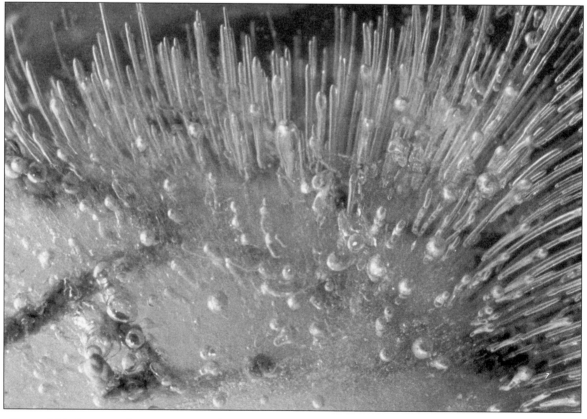

Above: *This "crown of ice" was created in the freezer. I added a few twigs to water in a glass dish, froze it, let it melt a bit, and refroze it. I photographed the design over a light box.*

Ideas to Try

- Explore the entire patch of frost, including icy edges. Shoot at various distances from the glass so you take in a lot of crystals or just a few.

- For variation, use a color filter on your lens.

- If the sun hits the frost so it sparkles, try a diffraction or star filter. (See pages 25 and 31)

- Bundle up and go outdoors to shoot close-ups of the snow. Position yourself low so blue sky is the background, or take along a sheet of blue paper and place it in the background.

Artificial Crystals

Pet stores sell small bottles of colored liquid to apply to the outside of an aquarium. It becomes crystallized when it dries. Paint a thin coat of this solution onto glass, let it dry, and photograph it over a light box. You can use more than one color for other effects. (See page 80)

Birefringence

Many colorless objects will surprise you by transforming into striking color when you put them on a light box between two pieces of polarizing material. Use a polarizing sheet (see source list in Appendix) on the light box, protected from scratches with a sheet of clear glass. Put a polarizing filter over the camera lens. (See page 78)

And the next time you fly, put a polarizer on your camera and shoot through the window--you'll add rainbows of colors to the landscape

Technical Details

You don't really have to understand birefringence (sometimes called double refraction) to appreciate the colorful beauty it produces. Some crystals and other transparent materials have a unique effect on light: when light passes through one of these birefringent substances, the light is split into two beams that are polarized at right angles to each other. If you place such a substance between two polarizers, an interesting thing happens. Light passes through the first polarizer, the birefringent substance splits the light into two beams, and one of the beams goes through the second polarizer. You'll see some beautiful colors, which will change as you rotate one of the polarizers. Engineers use this technique for stress analysis; we use it for making pretty pictures.

Birefringent Materials

- Clear plastic boxes (a CD jewel case is excellent), picture frames, spoons.

- Cellophane — crumpled or layered.

- Clear (not frosted) cellophane tape — crisscross many layers of it.

- Clear plastic packaging tape — folded, rippled, wrinkled, and twisted.

"Some crystals and other transparent materials have a unique effect on light."

- Plastic bag--stretch, pull, and tear it.

- Plastic bubble wrap.

- Thin slices of mica and other rocks.

- Whatever else seems promising; you'll never know until you try them.

Soap Bubbles

Who isn't fascinated by the ever-changing iridescent colors of soap bubbles? You can photograph lots of bubbles, one bubble, or just the thin skin of the multicolored soapy mixture. You'll get the richest colors if you shoot the bubbles in front of a black background. (See page 79)

The recipe for a good soap-bubble mixture is about two cups of warm water, four tablespoons of liquid dishwashing detergent, and four tablespoons of glycerine. The glycerine helps make the bubbles last longer.

Lots of Bubbles

 Camera Requirement: Aperture control

How To Do It

1. Line a large bowl with black plastic (such as a section of a plastic trash bag). Alternatively, use a glass bowl placed on black paper.

2. Set the bowl near a large window or sheet of white cardboard. Position the camera on a tripod so it looks down on the bowl.

3. Set the aperture to f/11 or f/22 to give you sufficient depth of field.

4. Put the soap-bubble mixture into the bowl.

5. Create bubbles by stirring the mixture gently with a fork or by blowing into it through a straw. Usually, you'll want large bubbles and only one layer thick, so don't mix vigorously.

6. Wait a few seconds until the bubbles stop moving and the colors show up, then take your pictures.

Ideas to Try

- Bracket your exposures. You may prefer those that are slightly underexposed.

- Use a star filter, diffraction filter, or a color filter. (See pages 22, 25, 31)

- Photograph really big bubbles.

- Use enough lens magnification so you can move the camera very close, filling the viewfinder with just one or two bubbles or even just part of a bubble.

- Use a child's bubble blower and try to capture the bubble while it hangs from the end of the blower.

"Who isn't fascinated by the ever-changing iridescent colors of soap bubbles?"

Soap Film

A thin film of the soapy mixture can catch gorgeous colors and fantastic patterns. You need a frame that the soap film can cling to. To make one, take a plastic food container (such as one for cottage cheese) or its cover, and cut away everything except the rigid rim. (See page 79)

 Camera Requirement: Shutter and aperture control

How To Do It

1. Work where sunlight can illuminate the setup from the side. Reflect it off a large white board, if necessary.

2. Use a sheet of black paper for a background.

3. Put the soapy water in a bowl large enough to accommodate the frame. Stir it well enough to blend the ingredients, not to make bubbles.

4. Dip the frame into the water and lift it out. A thin film of soap will stretch across the frame and will stay there for about 30 seconds.

5. Hold the frame vertically, in front of the background. Adjust its position until it catches the light and you see the colored patterns.

6. Take the picture using a shutter speed of 1/250 sec and an aperture of f/16 or f/22. Bracket your exposures.

Alternative Method

If the sunlight isn't bright enough to let you use the suggested aperture and shutter speed, you can use electronic flash or a photoflood lamp. To find the best position for a flash, shine light on the soap film from a small lamp. Then replace the light with the electronic flash.

Miscellaneous Subjects to Photograph

Here are a few more things to photograph that seem to defy categorization.

- Oil floating in street puddles after a rain.

- Small amounts of food coloring (one color or several) dropped into a glass container of water, backlit with diffused light. Shoot close up so you photograph only the colors swirling and diffusing in the water. Try it both in and out of focus. (See page 80)

- Reflections in rippling water.

- Reflection of neon lights on a wet street.

- Other things very close up. Walk around the house with a closeup lens and explore all sorts of common objects, from discolored copper pans to discarded pieces of fabric.

- Use front projection on either a textured screen or a regular projection screen, but deliberately distort the image by placing the projector at an angle to the screen. (See page 80)

"Reflections of neon lights on a wet street."

Appendix

Black Backgrounds

When you photograph subjects against a black background, make the first shot on the roll against a lighter background. And tell the lab. Otherwise, the lab may not be able to tell where one frame ends and the other begins.

Color Film and Tungsten Light

Tungsten light—the light from household lamps, photoflood lamps, and projector lamps— is actually somewhat redder than light from the sun. You may not notice it, but film will. Slide film comes in a version for indoor shooting (labeled tungsten) and outdoor (daylight) shooting, so you'll want to get the right one. Light from an electronic flash gives the same color as sunlight. Blue photoflood lamps come very close to the the color of sunlight.

All 35mm color print film is balanced for daylight. But if you shoot a special-effect photograph by tungsten light, it probably will look okay or even better. Also, the lab that processes your film can color correct the print if you ask.

If you want to make sure the color is correct, use a number 80A light-balancing filter on your camera lens. This blue filter also robs nearly two stops of light, so you'll need to increase your exposure. Cameras with TTL metering will do it automatically.

Very Long Exposures (Reciprocity Failure)

With exposures that last more than one second, the sensitivity of some film decreases. This probably won't be a problem until you go to ten seconds and more. Many films will then require one more stop of exposures. Either open the aperture a stop or double the exposure time.

You may also want to use a color-correction filter, since each color layer of the film reacts differently to the exposure time. The film manufacturer will give specific recommendations. But since special-effects photography is not about realism, generally you won't have to do anything about it. Also, a lab can make certain color corrections for you when making prints.

Close-Up Photography

When shooting closeups, you'll magnify every little camera shake as well as the subject. Be sure to use a tripod. It's also wise to release the shutter with a cable release or by using the self timer. A macro lens will let you focus on subjects that are very close to the camera. A telezoom lens with macro capability also lets you shoot close up. If you don't have either of these, visit your camera store and check out these options: supplementary close-up lens, sometimes called close-up filter; extension tubes, also called extension rings; bellows; or reversing ring.

Loading and Reloading Film for Making Double Exposures

1. Bring the film leader over to the take-up spool. Use a pen that writes on plastic (Sharpie, Pilot SCU-F, or similar) and draw a line on the film next to the lip on the film cartridge. Close the film chamber and advance the film as usual.

2. After shooting, rewind the film. If your camera does not leave the leader extending from the film cartridge, use a "leader retriever" to pull a bit of the film out of the cartridge.

3. Reload the film, pulling the leader to the take-up spool, and making sure the line you drew is next to the edge of the film cartridge.

Color Theory

In order to predict what will happen when you shine different color lights on a subject or when you multiple-expose your film using colored filters, you need to know what happens when the colors overlap. Light acts differently than pigments, so forget what you learned in kindergarten.

The primary colors of light are red, green, and blue. Combine all three and you'll get white light. Here's what happens when you combine two colors of light:

	RED	**GREEN**	**BLUE**
RED	Red	Yellow	Magenta
GREEN	Yellow	Green	Cyan
BLUE	Magenta	Cyan	Blue

The color of an object depends on its ability to reflect certain colors, and those colors must be present in the light shining on it. Since white light contains all colors, objects illuminated by white light can have many colors, depending on their pigments. But if you filter the light, their colors may change. Objects that are white or the same color as the light will have the color of the light, and objects that don't contain that color will darken.

> "...you need to know what happens when the colors overlap."

For example, shine a red light on a red or white surface and the object will appear red. Shine it on something yellow and it also will look red, because yellow reflects both red and green. But shine a red light on a blue object, and it will appear almost black because there's no color in the light that the blue object can reflect.

Appearance of pigments when a colored filter is used over the light source or in front of the camera lens.

		PIGMENT COLOR		
		RED	**GREEN**	**BLUE**
LIGHT COLOR	RED	Red	Black	Black
	GREEN	Black	Green	Black
	BLUE	Black	Black	Blue

Making It

Stand for Holding Textured Glass, Foam Board, Rear-Projection Material, Etc.

These dimensions are suggestions. Alter them as you wish.

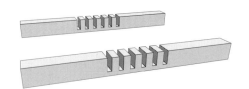

You'll need two 2x2-inch pieces of wood, 24 inches long. Cut grooves in each piece, approximately 1/2 inch wide and 1 1/2 inches deep, spaced at one-inch intervals. Set the pieces of wood parallel to each other, and you can stand the boards.

Substitute Light Box

1. The best surface is a sheet of opal or frosted glass or plastic. A large glass dinner plate may also work for small subjects.

2. You can also use clear glass if you lay a sheet of tracing paper on top of it to diffuse the light.

3. Safely support the glass on anything that will raise it high enough for you to illuminate it from underneath.

4. Place a light source underneath the glass, reflecting it off white cardboard and up through the glass. This will give you an even light without a hot spot.

Suppliers: Manufacturers And Distributors

Art Supplies, Mail Order

Dick Blick
P.O. Box 1267
Galesburg, IL 61402

A.I. Friedman
44 W. 18th Street
New York, NY 10011

Filters

Ambico

2950 Lake Emma Road
Lake Mary, FL 32746

B+W

Schneider Corporation
400 Crossways Park Drive
Woodbury, NY 11797

Beauty

Porters Camera Store
P.O. Box 628
Cedar Falls, Iowa 50613

Cokin

Minolta Corporation
101 Williams Drive
Ramsey, NJ 07446

Hama
Dotline Corporation
9420 Eton Avenue
Chatsworth, CA 91311

Hoya
THK Photo Products
1512 Kona Drive
Compton, CA 90220

Marumi
Argraph Corporation
111 Asia Place
Carlstadt, NJ 07072

Master Control System
(See Tiffen)

Pro-Optic
Adorama
42 West 18th Street
New York, NY 10011

Tiffen
Tiffen Manufacturing Company
90 Oser Avenue
Hauppauge, NY 11788

Wratten
Eastman Kodak Company
343 State Street
Rochester, NY 44

Gels

Edmund Scientific Company
101 E. Gloucester Pike
Barrington, NJ 08007

Porters Camera Store
P.O. Box 628
Cedar Falls, Iowa 50613-0628

Rosco Laboratories, Inc.
26 Bush Avenue
Port Chester, NY 10573

Glass And Plastic, Textured

Your local glass store

Fluorescing Makeup

Alcone
5-49 49th Avenue
Long Island City, NY 11101

The Makeup Center
150 West 55th Street
New York, NY 10022

Masks, Slide

Porters Camera Store
P.O. Box 628
Cedar Falls, Iowa 50613-0628

Matte Boxes, Masks, Vignetters

Ambico
2950 Lake Emma Road
Lake Mary, FL 32746

Lindahl Specialties Inc.
P.O. Box 1365
Elkhart, IN 46515

Mylar, Silver

See Art Supplies, mail order

Polarizing Sheets

Edmund Scientific Company
101 E. Gloucester Pike
Barrington, NJ 08007

Rear-Projection Screens

Porters Camera Store
P.O. Box 628
Cedar Falls, Iowa 50613-0628

Slide Mounts, Glass Covered

Wess Plastic, Inc.
70 Commerce Drive
Hauppauge, NY 11788

Gepe, Inc.
257 Farmview Drive
Macedon, NY 14502

Ultraviolet (UV) Lamps (Black Light)

Edmund Scientific Company
101 E. Gloucester Pike
Barrington, NJ 08007

Miscellaneous Camera Products (almost everything your camera store doesn't have)

Porters Camera Store
P.O. Box 628
Cedar Falls, Iowa 50613-0628

Glossary

Aperture: The opening in the camera lens that admits light. Aperture size is written as an f-number; the larger the number, the smaller the opening.

Aperture-priority mode: An automatic-exposure mode in which the photographer sets the aperture and the camera selects the correct shutter speed for that aperture.

Backlighting: Light that comes from behind the subject, toward the camera, illuminating the subject from behind.

Birefringence: The splitting of a light wave into two unequally reflected waves by an optically anisotropic medium. (Aren't you sorry you asked?) Also called "double refraction."

Bracketing: Taking additional pictures of a subject through a range of exposures over and under the metered reading.

Bulb (B) exposure: When set on B, the shutter remains open as long as the shutter-release button is pressed. For very long exposures, it's convenient to use it with a locking cable release. Compare with "time exposure."

Depth of field: The area between the nearest and farthest subjects that appear to be in focus.

Depth-of-field preview: A feature that closes the lens down to the taking aperture — the aperture it will be when you make the exposure. This way, you can see what areas will be in and out of focus.

Fast film: Film with a great sensitivity to light, enabling you to photograph when the light is not bright. Films with ISOs of 400 and higher are considered fast films.

Field of view: The area of the scene that the lens can record. A wide-angle lens takes in a broader area than a telephoto lens.

Film plane: The place behind the lens where the film lies.

Front-silvered mirror; front-surfaced mirror: A mirror whose reflective silver coating is on the front of the glass instead of the back, resulting in a sharp reflection with no ghost image.

Gel: Short for gelatin, referring to the gelatin filters used in photographic lighting. They are available in small sample sizes for various creative applications.

Gray Card: A piece of gray cardboard that reflects 18 percent of the light falling on it. This is approximately the same amount of light reflected by an average scene. If the overall scene is brighter or darker than average, or if a small subject is surrounded by bright or dark background, metering the gray card will give the correct reading.

Litho film: A film that produces extremely high-contrast images with opaque blacks, transparent white, and no mid-tones when processed in a special developer.

Macro lens: A lens that allows you to focus at a very close distance from the subject.

Mask: Piece of vinyl or lightweight cardboard with a shaped opening, for use in front of the lens. Masks made of thin material can be put together with slides.

Matte box: Front-of-the lens device with an expandable bellows. It acts as a lens shade, has a slot in back for square or gelatin filters, and a front slot that can hold masks and vignetters.

Mylar: A thin polyester film with a highly reflective surface. It is available in art stores

Neutral-density (ND) filter: A gray filter that reduces the amount of light entering the lens without affecting the color of the image.

Panning: Moving the camera while photographing a moving subject, keeping the subject's image in the same place in the viewfinder.

Polarizing filter: A filter that transmits light traveling in only one plane.

Rear projection: Setup in which the projector is in back of a special screen and the image is viewed from the opposite side.

Sandwiching: Combining two pieces of slide film in one slide mount.

Selective focusing: Using a shallow depth of field to isolate a subject.

Silhouette: A subject that appears dark and featureless against a light background.

Slave: A flash unit with a sensor, which causes the flash to fire virtually simultaneously with another flash.

Slow film: Film with a low sensitivity to light, requiring a great deal of light for adequate exposure. Any film with an ISO number of 64 or lower is considered a slow film.

Step-down ring: Adapter ring that enables you to use a filter that has a smaller diameter than the lens.

Step-up ring: Adapter ring that enables you to use a filter that has a larger diameter than the lens.

Time exposure: When set on T, the shutter remains open from the time it is pressed until it is pressed a second time. Compare with "Bulb exposure."

TTL: The abbreviation for through the lens. With a TTL viewfinder, what you see through the viewfinder is what will be recorded on film.

Vignetting: Corners of the image are darkened by the interference of a filter that's too small, too many stacked filters, or the wrong-size lens shade for the lens. For creative effects, a vignetting device (vignetter) can be put in front of the lens to darken or lighten the area surrounding the image or part of the image.

Index

Boldface numbers refer to color photographs

Amherst Media's Customer Registration Form

Please fill out this sheet and send or fax to receive free information about future publications from Amherst Media.

CUSTOMER INFORMATION

DATE

NAME

STREET OR BOX #

CITY STATE

ZIP CODE

PHONE () FAX ()

OPTIONAL INFORMATION

I BOUGHT *SPECIAL EFFECTS PHOTOGRAPHY HANDBOOK* BECAUSE

I FOUND THESE CHAPTERS TO BE MOST USEFUL

I PURCHASED THE BOOK FROM

CITY STATE

I WOULD LIKE TO SEE MORE BOOKS ABOUT

I PURCHASE BOOKS PER YEAR

ADDITIONAL COMMENTS

FAX to: 1-800-622-3298

Name_____

Address_____

City_____State_____

Zip_____ — _____

Amherst Media, Inc.
PO Box 586
Buffalo, NY 14226

Other Books from Amherst Media, Inc.

Basic 35mm Photo Guide
Craig Alesse

Great for beginning photographers! Designed to teach 35mm basics step-by-step — completely illustrated. Features the latest cameras. Includes: 35mm automatic and semi-automatic cameras, camera handling, *f*-stops, shutter speeds, and more! $12.95 list, 9x8, 112p, 178 photos, order no. 1051.

Infrared Photography Handbook
Laurie White

Covers black and white infrared photography: focus, lenses, film loading, film speed rating, heat sensitivity, batch testing, paper stocks, and filters. Black & white photos illustrate how IR film reacts in portrait, landscape, and architectural photography. $24.95 list, 8½x11, 104p, 50 b&w photos, charts & diagrams, order no. 1419.

Wedding Photographer's Handbook
Robert and Sheila Hurth

The complete step-by-step guide: everything you need to start and succeed in the exciting and profitable world of wedding photography. Packed with shooting tips, equipment lists, must-get photos, business strategies, and much more! $24.95 list, 8½x11, 176p, index, b&w and color photos, diagrams, order no. 1485.

Lighting for People Photography
Stephen Crain

The complete guide to lighting and its different qualities. Includes: set-ups, equipment information, controlling strobe and natural lighting, and much more! Features diagrams, illustrations, and exercises for practicing the lighting techniques discussed in each chapter. $29.95 list, 8½x11, 112p, b&w and color photos, glossary, index, order no. 1296.

Handcoloring Photographs Step by Step
Sandra Laird & Carey Chambers

The new standard reference for handcoloring! Learn step-by-step how to use a wide variety of coloring media, such as oils, watercolors, pencils, dyes and tones, to handcolor black and white photos. Over 80 color photos illustrate how-to handcoloring techniques! $29.95 list, 8½x11, 112p, color and b&w photos, order no. 1543.

Telephoto Lens Photography
Rob Sheppard

A complete guide for telephoto lenses! This book shows you how to take great wildlife photos, portraits, sports and action shots, travel pics, and much more! Features over 100 photographic examples. $17.95 list, 8½x11, 112p, b&w and color photos, index, glossary, appendices, order no. 1606.

Wide-Angle Lens Photography
Joseph Paduano

For everyone with a wide-angle lens or people who want one! Includes taking exciting travel photos, creating wild special effects, using distortion for powerful images, and much more! Part of the Amherst Media's Photo-Imaging Series. $15.95 list, 7x10, 112p, glossary, index, appendices, b&w and color photos, order no. 1480.

Great Travel Photography
Cliff and Nancy Hollenbeck

Learn how to capture great travel photos from the Travel Photographer of the Year! Includes helpful travel and safety tips, packing and equipment checklists, and much more! Packed full of photo examples for all over the world. Part of the Amherst Media's Photo-Imaging Series. $15.95 list, 7x10, 112p, b&w and color photos, index, glossary, appendices, order no. 1494.

Big Bucks Selling Your Photography
Cliff Hollenbeck

A complete photo business package for all photographers. Includes secrets to making big bucks, starting up, getting paid the right price, and creating successful portfolios! Features setting financial, marketing and creative goals. This book helps to organize business planning, bookkeeping, and taxes. $15.95 list, 6x9, 336p, order no. 1177.

Special Effects Photography Handbook
Elinor Stecker Orel

Create magic on film with special effects! Little or no additional equipment required, use things you probably have around the house. Step-by-step instructions guide you through each effect. $29.95 list, 8½x11, 112p, 80+ color and b&w photos, index, glossary, order no. 1614.

Infrared Nude Photography

Joseph Paduano

A stunning collection of images with informative how-to text. Over 50 infrared photos presented as a portfolio of classic nude work. Shot on location in natural settings, including the Grand Canyon, Bryce Canyon and the New Jersey Shore. $29.95 list, 8½x11, 96p, over 50 photos, order no. 1080.

Glamour Nude Photography

Robert and Sheila Hurth

Create stunning nude images! Robert and Sheila Hurth guide you through selecting models, choosing locations, lighting, shooting techniques, posing, equipment, makeup, and much more! $24.95 list, 8½x11, 144p, over 100 b&w and color photos, index, order no. 1499.

Swimsuit Model Photography

Cliff Hollenbeck

The complete guide to the business of swimsuit model photography. Includes: finding models, selecting equipment, posing, using props and backgrounds, and much more! $29.95 list, 8½x11, 112p, over 100 b&w and color photos, index, order no. 1605.

McBroom's Camera Bluebook

Mike McBroom

Comprehensive and fully illustrated, with price information on: 35mm cameras, medium & large format cameras, exposure meters, strobes and accessories. Pricing info based on equipment condition. A must for any camera buyer, dealer, or collector! $29.95 list, 8½x11, 224p, 75+ photos, order no. 1263.

Build Your Own Home Darkroom

Lista Duren & Will McDonald

This classic book shows how to build a high quality, inexpensive darkroom in your basement, spare room, or almost anywhere. Information on: darkroom design, woodworking, tools, and more! $17.95 list, 8½x11, 160p, order no. 1092.

Into Your Darkroom Step-by-Step

Dennis P. Curtin

The ideal beginning darkroom guide. Easy to follow and fully illustrated each step of the way. Information on: equipment you'll need, set-up, making proof sheets and much more! $17.95 list, 8½x11, 90p, hundreds of photos, order no. 1093.

Camera Maintenance & Repair

Thomas Tomosy

A step-by-step, fully illustrated guide by a master camera repair technician. Sections include: testing camera functions, general maintenance, basic tools needed and where to get them, basic repairs for accessories, camera electronics, plus "quick tips" for maintenance and more! $24.95 list, 8½x11, 176p, order no. 1158.

Camera Maintenance & Repair Book 2: Advanced Techniques

Thomas Tomosy

Building on the basics covered in the first book, this book will teach you advanced troubleshooting and repair techniques. It's easy to read and packed with photos. An excellent reference and companion book to *Camera Maintenance & Repair*! $29.95 list, 8½x11, 176p, order no. 1558.

Restoring Classic & Collectible Cameras

Thomas Tomosy

A must for camera buffs and collectors! Clear, step-by-step instructions show how to restore a classic or vintage camera. Work on leather, brass and wood to completely restore your valuable collectibles. $34.95 list, 8½x11, 160p, b&w photos and illustrations, glossary, index, order no. 1613.